BACK TO JAPAN

"Marc Petitjean's wonderfully compact book delivers an intimate account of the kimono in modern times from the unique perspective of one of its most esteemed practitioners, kimono painter and Living National Treasure Kunihiko Moriguchi. More than his kimono designs, we learn about the place of the kimono and its arts in contemporary times through Moriguchi's eyes — from growing up as the son of a renowned kimono painter during the postwar poverty of Japan, escaping to Paris to find a new context for his art, and returning to Japan to define his art's own context. *Back to Japan* centers on this life-changing decision. Petitjean gives a candid portrayal of his friend and artist who fiercely protected his creative voice while proudly carrying on the artistic tradition in kimono of permanent innovation."

— **VIVIAN LI,** Lupe Murchison Curator of Contemporary Art,
Dallas Museum of Art, and coauthor of
Kimono Couture: The Beauty of Chiso

"Kimono designer Kunihiko Moriguchi is a 'Living National Treasure,' the highest cultural recognition bestowed in Japan. But he is not simply preserving a tradition. He has absorbed a modern Western aesthetic, creating his own unique style. This is the story of how he grew up enfolded in a traditional family, learning skills from his father, then leaping into the art world of Paris in the 1960s, only to discover that his true calling lay

back home in Kyoto. A rare cosmopolitan figure in the world of Japanese traditional crafts deemed worthy of Intangible Cultural Heritage status, Moriguchi is portrayed through the eyes of his French friend, filmmaker Marc Petitjean, for whom Moriguchi is a portal for understanding deep Japanese sensibilities. An intimate and engrossing portrait of an artist's life within French and Japanese culture."

—**LIZA DALBY,** author of *Geisha* and *The Tale of Murasaki*

"Marc Petitjean's *Back to Japan: The Life and Art of Master Kimono Painter Kunihiko Moriguchi* is an exquisite journey into the life trajectory and work ethos of Moriguchi. While painting a vivid portrait of the master, Petitjean also describes the eternal conflicts of modernity vs. tradition, art and artisanal thought processes, and cross-cultural otherness. This book is a rare glimpse into this rarified world and is written with sensitivity and skill."

—**MANAMI OKAZAKI,** author of *Kimono Now*

"*Back to Japan* highlights the way art crosses borders — temporal and geographical — and weaves together friendships and family legacies. At once moving and profound, the book follows the life course of a son who, in sacrificing his own passions, discovers new modes of expression in the elegant folds and shadows of traditional *yuzen* dyeing. Marc Petitjean's riveting portrait of textile artist Kunihiko Moriguchi is more than biography; it is a testimony to the 'dynamic dignity' this art requires."

—**REBECCA COPELAND,** Professor of Japanese Literature, Washington University in St. Louis, and author of *The Kimono Tattoo*

"Through his personal interaction with the textile artist, Marc Petitjean narrates a captivating biographical story of Kunihiko Moriguchi, who is a direct successor of the long history and technique of *yuzen*, a paste-resist method of dyeing invented in the second half of the sixteenth century. Moriguchi combined Japanese tradition and Western modernity to create unique and original geometrical designs that are now his trademark. The book details his upbringing in Kyoto, his experiences in France, and influences from his mentors, such as his father and Balthus, all of which shaped who he is today as Japan's Living National Treasure. The book is a must-read for anyone who is interested in Japanese art and culture."

—**YUNIYA KAWAMURA**, Professor of Sociology,
Fashion Institute of Technology, and author of
The Japanese Revolution in Paris Fashion

"Marc Petitjean takes readers on a remarkable journey into the life and art of Kunihiko Moriguchi, a Living National Treasure and one of the great masters of *yuzen*. From the galleries of Paris to the strict workshops of Kyoto, *Back to Japan* offers an intimate glimpse of an artist who at once preserves and revolutionizes a centuries-old art form. Petitjean's poetic and heartfelt prose, along with Moriguchi's extraordinary creations, will linger in your imagination long after you close the pages."

—**VIRGINIA SOENKSEN**, Director,
Madison Art Collection and Lisanby Museum,
and coauthor of *Textiles of Japan*

ALSO BY MARC PETITJEAN

The Heart: Frida Kahlo in Paris

BACK TO JAPAN

◆ ◆ ◆

The Life and Art of
Master Kimono Painter
Kunihiko Moriguchi

MARC PETITJEAN

Translated from the French by Adriana Hunter

Other Press | New York

Library of Congress Cataloging-in-Publication Data

Names: Petitjean, Marc, author. | Hunter, Adriana, translator. |
Petitjean, Marc. Ami japonais.

Title: Back to Japan : the life and art of master kimono painter Kunihiko
Moriguchi / Marc Petitjean ; translated from the French by Adriana Hunter.

Other titles: Ami japonais. English

Description: New York : Other Press, [2021]New York : Other Press, [2021] |
"Originally published in 2020 as L'Ami japonais: Kunihiko Moriguchi,
trésor vivant, peintre de Kimonos by Arléa, Paris."

Identifiers: LCCN 2021008267 (print) | LCCN 2021008268 (ebook) |
ISBN 9781635420906 (hardcover) | ISBN 9781635420913 (ebook)

Subjects: LCSH: Moriguchi, Kunihiko, 1941– | Textile designers—Japan—
Biography. | Expatriate designers—France—Paris—Biography. |
Jūyō Mukei Bunkazai Hojishakai—Biography.

Classification: LCC NK9502.5.M67 O4813 2021 (print) |
LCC NK9502.5.M67 (ebook) | DDC 746.092 [B]—dc23

LC record available at https://lccn.loc.gov/2021008267

LC ebook record available at https://lccn.loc.gov/2021008268

TO FREYDELYNE AND KEIKO

MEETING

AS NIGHT FELL the taxi dropped me by the entrance to the Okura, a luxury hotel in Tokyo's embassies neighborhood. A friend in Paris had put me in touch with his "Japanese brother." This was our first meeting. As I crossed the lobby to the bar, I was struck by the sense of harmony inherent in the spaces and materials in this building that dated from the 1960s: a combination of the modern and the traditional.

Cut-glass droplets of light hung from the ceiling, and armchairs were arranged like petals around circular tables on carpeting in a checkerboard of warm colors. The walls were clad in pale wood and the views softened by paper screens. From a distance I watched the female staff elegantly going about their work in their pastel-colored kimonos. The Orchid Bar had an English-style muted feel.

Kunihiko Moriguchi came to greet me with a broad smile: "Ah, Marc!" We settled into black leather armchairs on either side of a beaten copper table, and ordered whiskeys.

He was slighter than I had imagined, spry with a warm smile and a handsome face. He spoke impeccable French, learned in Paris in the 1960s, but, to his regret, he hadn't had occasion to improve it since. We drank to our mutual friend and to our reciprocal attraction: his to France and mine to Japan.

My first visit had been two years earlier for the shoot of a documentary about Dr. Hida, a survivor of the Hiroshima bomb. He was a committed, charismatic man who devoted himself to treating survivors of injury and radiation, and I saw him as a modern hero who had succeeded in reconciling communism with Buddhism.

Moriguchi told me about Japanese culture and his concept of art; his words gave me glimpses of a society I hardly knew, having discovered it through the very distinctive prism of atomic bombs. As we were about to say goodbye, something gave me pause. I experienced that mysterious feeling afforded by all true meetings of minds.

As if throwing a message in a bottle into the sea, I said I'd very much like to make a film about him and his kimonos, if the opportunity arose someday. The idea appealed to him. It could very easily have melted away like snow in sunshine.

Back at my hotel I leafed through the catalogue of his painted kimonos. I was expecting traditional designs,

branches of cherry blossom, waves, pagodas. Instead, I discovered geometric patterns in incrementally fading colors that sublimated the very notion of kimonos.

He had given me a leaflet about the Hotel Okura, making a point of saying how much he liked it. The architects Yoshiro Taniguchi and Hideo Kosaka had combined modernist architecture and age-old traditions of Japanese craftsmanship. Moriguchi claimed he himself adhered to such tendencies. The Hotel Okura was destroyed in 2015 to make way for a thirty-eight-story tower, taking with it memories of its famous guests: Yoko Ono and John Lennon, Madonna, Herbert von Karajan, Barack Obama, Jacques Chirac, and so many more. The nostalgic can always watch *Walk, Don't Run*, a film starring Cary Grant that used the hotel as a location in 1966.

True, buildings in Tokyo are regularly razed to the ground and replaced after twenty or thirty years' service. As such, Tokyo is not so much a city of memories as a city of things to come.

◆ ◆ ◆

IN JAPAN memories seem to be incarnated by people rather than monuments. In a country chronically prone to earthquakes, tsunamis, fires, volcanic eruptions, and typhoons, the Japanese know that houses, villages, and whole landscapes can be damaged or entirely erased from one day to the next. On the other hand, the people who survive these

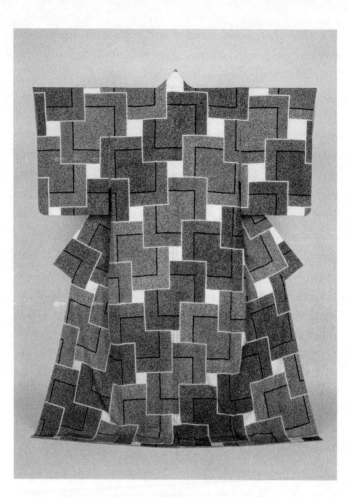

Kunihiko Moriguchi, *Topology — squares*, 2006
A trompe l'oeil of squares reminiscent of *shikishi* (paper squares)
used for calligraphic poems and drawings.

disasters are able to pass on their know-how from generation to generation, so that, to take just one example, houses can be rebuilt in keeping with ancient Japanese traditions. This is how traditional forms of architecture, art, theater, and craftsmanship have been kept alive, passed on and reproduced for centuries right up to the present day.

In 1950 — turning its back on the war and a disastrous colonial past, and in reaction to the horrors of the Hiroshima and Nagasaki bombs — the Japanese state decided to establish culture as a higher value in the new society that was being founded. It was in the context of this initiative that the term "Living National Treasure" emerged to honor artists seen as guardians of intangible but significant cultural assets. Kunihiko Moriguchi was awarded the distinction of Living National Treasure in his capacity as a textile artist (in the so-called *yuzen* tradition established by Miyazaki Yuzen in the Edo period), and therefore became a "human monument."

One point niggled at me: Moriguchi's abstract kimono patterns were light-years away from the designs I knew, ones that represented the sort of traditions that the notion of Living National Treasures seemed intended to reference. How did the commissioners for a tradition-based concept of Japanese culture justify this fusion of ancient and modern, Western and Japanese culture? And on a more personal level, how had Moriguchi carved out this niche between these two worlds?

OTHERNESS

ONE FINE MORNING four years after that first meeting at the Okura, I found myself outside Kunihiko Moriguchi's house with a video camera, ready to invade the premises. We had agreed that I could film everything over the three months that I was to stay in Kyoto. He was opening his doors wide to me and was committed to ensuring that I discovered — and loved — Japanese culture. He often said, with a mischievous smile, "We're very different, but we can still talk to one another and try to draw closer."

After New Year's, he invited me to a tea ceremony arranged by the Matsushita Foundation. At its origin, the tea ceremony was a traditional art inspired by Zen Buddhism. The intention is that, during the course of this lengthy, codified ritual, participants are freed of their personal trappings to

share in an esthetic experience. The villa where it was held is called Shinshin-An, which means "truth of truth." Its grounds were there for all to see before the dark, concealed modern building. Silent gardeners hunkered down and gathered the pine needles strewn on the ground, picking them up one by one, then patiently assembled them side by side to form a covering to protect the various mosses from the rigors of winter. This humble consideration for the natural world touched me and persuaded me to take a closer look at the treasure to which they were ministering with such perfect care. I surrendered to the mood exuded by the place. The orangey-brown of the pine needles struck up conversation with the different greens of mosses and the grays of stones. In the distance, behind the gardeners, the view was shaped by the garden's great variety of trees arranged in a succession of tiers that gradually melted into the wooded slopes of Mount Higashiyama. Exploring the garden was a preamble to the tea ceremony. In addition to the spectacular panoramic composition that greeted visitors when they set foot on the grounds, its designers had devised a carefully planned itinerary so guests could explore the different spaces by taking a variety of paths. Parts of the garden were hidden and then revealed along the way, appearing from behind a tree, a shrub, a mound of earth, or a small wooden bridge. I felt as if the scenery changed as I walked, unveiling a succession of new architectural and botanical themes: mosses and bodies of water, wild trees and pruned trees, a dry garden of methodically raked sand dotted with evergreens, sculptures, a small tea pavilion...At

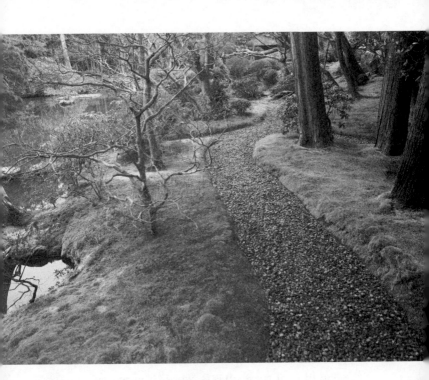

Garden at Shinshin-An Villa

the end of this journey stood a Shinto sanctuary, a miniature replica of the Jingu temple in Ise. Matsushita had had it built to express gratitude and respect for "the origin and supreme power of the universe." It was here that multi-millionaires came to marshal their thoughts before making major decisions about the future of their businesses.

There were about ten of us, all men in dark suits, seated in a semicircle facing Mr. Tokuda, the master of ceremonies, who was guided by a woman in a light-green kimono. The mood was relaxed and cordial. He encouraged us to try the welcome pastries from Tsuruya Yoshinobu, and to eat them with our fingers, uninhibitedly. Then Tokuda presented some ancient chinaware, bowls and pots that were passed around carefully, each of us marveling at them and noting every tiny detail like connoisseurs. "Oohs" and "ahs" and other — more Japanese — exclamations accompanied the handling of these objects, whose beauty I failed to see. Kunihiko Moriguchi whispered a translation of the enthusiasts' comments as they handed the pieces to the next person: "You can appreciate it so much better when you can feel its rough surface, rather than just seeing it," one said. "I'm fascinated by the shape of this bowl. I can see Mount Fuji in it, and the moon," said another. Or, "Is that a calabash or a rabbit I can make out here?" They saw fantastical things that transported them far away, while I saw nothing. As consolation, I smiled to myself and remembered a reflection of Claude Lévi-Strauss: cultures are by their very nature incommensurable.

Next Mr. Tokuda showed us the utensils used for the ceremony: "The kettle—*shin narigama*—was made by the master Ikke, the jug by master Eiraku Zengoro XVI (Sokuzen). The tea caddy was designed by Gengensai of Urasenke, and the spoon by Tantansai...I seem to have forgotten the name of the piece...Oh, yes, it's called Yukei."

"*Yukei* means 'having feelings of joy,'" the woman in the kimono added lightly.

"She's my teacher and I'm not a good student."

"Nonsense," she said gently. "He's in the third year of his apprenticeship, and it's good experience for him to do a presentation in front of his teacher."

"I'm terrified because I feel like I've forgotten everything," he admitted, laughing.

We were served tea in equally remarkable bowls, and, with my thumb inside it, I turned mine around until the pattern was facing me, as I had been taught to do. Only then did I bring it to my lips to sip the tepid green froth of matcha. Mr. Tokuda explained that he had chosen to serve us using bowls that Mr. Matsushita liked in the hope that, as he did, we would sense the spirit of their shape and substance that conjure a historical depiction of the afterlife. Young women in kimonos delicately set down trays laden with exquisite food, and served us as much sake as we wanted. Moriguchi translated the conversations around us for me. "People in Japan think that black and white are colors of mourning, but funeral directors came up with that idea. Black and white are actually the colors of happiness. Bereavement is a happy thing, because when someone dies

they are reincarnated in Buddha. Black and white are the basis for everything."

I had plenty to think about.

Konosuke Matsushita was the legendary founder of Panasonic, the first big Japanese electronics company. He succeeded in combining rigorous discipline with technological power to conquer Japanese and international markets. At the same time, he defended and subsidized the conservation, exhibition, and very survival of Japanese arts and crafts. In Matsushita I once again saw that coexistence of the modern and the traditional, and I also found out that the Japanese could relax their reserve like children and go into ecstasies over old bits of pottery that I found unexceptional. Moriguchi explained later that the bowls were true "phenomena" of the history of earthenware and were utterly priceless. Some of the guests held their bowls over a cushion on the ground just in case they dropped them out of clumsiness or an excess of emotion.

To circumvent laws that forbade the exhibition of costly luxury belongings, rare and precious items had been banished in favor of cheap, humdrum ones from everyday life, handmade things complete with imperfections. Kunihiko was very keen that I should understand exactly what was going on. Perhaps he thought that if I didn't like what I saw that day, then this venture would be a lost cause and I wouldn't be equipped to go any further in exploring his culture.

CHILDHOODS

KUNIHIKO MORIGUCHI was born in Kyoto in 1941. His father, Kakō, a kimono painter, suffered the restrictions imposed on the Japanese population by the military and stopped work in his studio. Fabric suppliers were requisitioned to help build decoy aircraft in wood and fabric, to mislead American pilots. Deemed too short to be a soldier, Kakō had to produce technical drawings, elevations and cross sections for the construction of cannons. In the evenings he brought home work, and Kunihiko remembers great rolls of paper, compasses, triangles, and rulers.

By the latter stages of the war, daily life was terrible. People had nothing to eat and the Allied victory seemed inevitable. American bombings intensified all over the country, and the chunky low-level drafting table at which Kakō usually

worked served as a roof over the shelter that had been dug in the garden to keep the family safe. Air raid warnings rang out at all hours, and Moriguchi spent whole nights in that shelter, clutching a pan of watery rice and huddled against his mother and brother, his eyes wide with terror at the thought of an explosion or a stomachache.

He has hazy memories of men demolishing the wooden houses at the end of his street by pulling on the ropes that secured their roof ridges. The new open space on Oike Avenue acted as a firebreak and gave the air force somewhere to land their planes. His family home, which was close to Nijō Castle, was in danger of being knocked down at any moment, so they moved to Fushimi in the suburbs. There, the young Moriguchi discovered a whole new life, closer to nature.

"Those were the days of short pants," he told me. "My knees were grazed and I wore sandals made of reeds or wooden geta. I fished in rivers and caught frogs, crawfish, and insects. One time I filled my school cap with caterpillars. I'd collected them in a cabbage patch next to my house, much to the delight of the field's owner, but not to my mother's — she hated insects and thought they were disgusting. I fed them on cabbage stalks, and one day I found their cage filled with yellow: they'd metamorphosed into butterflies."

His aunt had a sewing workshop near the barracks for the Thirty-Seventh Regiment of the land army. She worked for the Japanese Army until 1945, and after Japan was defeated, her new clients were officers in the American occupying

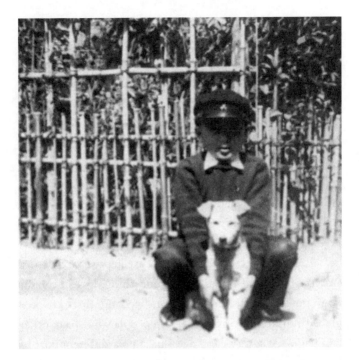

Kunihiko Moriguchi, age twelve

forces. In 1946, Kunihiko started kindergarten. He walked past his aunt's house every day and took to spending time there on his way home. She became very fond of him and even suggested to his parents that she could adopt him. He had a wonderful time in her house, meeting American soldiers and eating corned beef and Hershey bars.

"When I was six, I discovered that there were black people, beige people, white people, and red people, and languages I didn't understand. Something else had an impact on me at school: when I was seven, as class president I was given the responsibility of looking after a little girl who was developmentally disabled, helping her read, play, and dress herself. Nowadays, disabled people are kept separate from everyone else, and that's not a good thing. I was brought up in poverty, but I learned about the world: there are people with disabilities, and there are people who speak other languages. At a very early age I became a different sort of Japanese with a more global outlook."

Kakō made use of his sister-in-law's customer base to set up a workshop where he crafted small squares of silk and drew flowers, cherry trees, and landscapes onto them to be embroidered. He then received commissions for military insignia and embroidery designs for the US Army's blue silk jackets, fashioning the words US ARMY or large depictions of bald eagles. This work kept the family alive during a period of great hardship.

The Americans did not leave Kunihiko with only pleasant memories. When they wanted to appropriate large

private houses in Kyoto, they painted a white stripe ten centimeters deep around each chosen house with no further preamble. This indicated that the owners must leave immediately. Then officers would arrive and take possession of the premises, moving in their Japanese mistresses under the protection of the military police.

After the war there was a radical change of mindset. The emperor had always been considered a god; after the defeat, he had become a man and a symbol of the country's unity. "For teachers who had to give their students such contradictory messages from one day to the next, it was really difficult. I know that my teacher in my first year of kindergarten took his own life. I think it was in the rainy season."

From 1951, during the Korean War, coal mines in the north of Kyushu and blast furnaces worked flat out for the US Army. Managers grew rich fast and became the new buyers of luxury kimonos, painted using the *yuzen* technique that Kakō Moriguchi practiced. Orders increased, and, with their circumstances now more favorable, Kakō managed to buy a house in 1952. It was his kimono wholesaler who loaned him the money: one million yen, to be repaid with his creations. The house, which had been built in 1911, was in the fabrics and dyeing neighborhood where they had lived before the war. The area around Nijō Castle is made up of streets that cross one another at right angles, and each block is about fifty meters wide. The houses on these streets have a narrow frontage but are quite deep, hence the nickname "eel's nest." House tax was apparently

determined by the width of the façade. It is also said that central Kyoto had often been a battlefield, and when a victorious warrior passed a beautiful house, he simply requisitioned it. To keep a low profile, people lived in these long, narrow houses with backyards. A tradition that persists.

When I first visited his family home, Kunihiko had told me about the living soul of this place where he had already lived for nearly sixty years. "Japanese houses are built of wood, bamboo, earth, and paper, and straw for the tatamis. Most of the materials need replacing nearly every year, and every ten years we slightly alter the structure. After twenty years, we rearrange the house to adapt to new lifestyles. So, the interior changes with shifting notions of life."

The huge workshop on the second floor had a low ceiling and was carpeted throughout with tatamis. It had no source of daylight, and the low tables at which the craftsmen worked were lit by lamps hanging from the ceiling. In Kakō's day, there could have been up to fifteen employees. Now there was just one. On the ground, the separate pieces of a kimono had been stretched onto light bamboo frames. The geometric shapes in fading shades of red gave an inkling of how complex the design was. Different sizes of paintbrush were hung on the walls like works of art.

When I set about filming the workshop, I asked Kuni — the affectionate diminutive for Kunihiko — not to pay any attention to me. I planned to film what I saw as I saw it, without set dressing or commentary. I wanted to render

the various gestures and actions in real time. The first predicament was finding where to put myself with my camera, as close as possible to him but respecting his personal space, what I called his "bubble." During the preparatory stages, when he had devised patterns on sheets of paper, he transferred them to the kimono in life size, complete with their layered geometric sequences. He was sitting on a tatami in a corner of the workshop with the kimono spread over a low wooden table. The thick, fluid silk of the kimono did not look like an easy surface on which to draw. And how did he orient himself with all those straight lines and geometric layers? It was a mystery. Still, I had decided to film this process, and, in order to see it through his eyes, I needed to position myself over his shoulder and zoom in on the part that he was drawing. I was then framing an area ten centimeters square, which is technically quite tricky because, in order to stay in focus, I could not move. I would normally have used a tripod for this sort of shot. As luck would have it, I did not have one, which meant I had to give it my full concentration. With the camera on my shoulder, I held my breath to avoid moving while I filmed. I did all the shots holding my breath, using my body as an axis and tipping it slightly to correct the focus if I lost it. Kuni, meanwhile, traced out his parallel lines almost freehand, with deft precision and a soft exhalation as he completed a movement. I expected him to make mistakes, but he did not. I was captivated, and this went on for some time, until I felt I had captured the very essence of his drawing technique. We were both in his "bubble," with him drawing and

me transfixed by the need to maintain the clarity of the image. We experienced those first moments — sharing the same space and concentrating on the same thing — in perfect harmony. We have never discussed it, but I feel that we had proof that day of the validity of our project. Nothing was predetermined; we had to experiment and throw ourselves into the adventure.

◆ ◆ ◆

AS WAS CUSTOMARY, when Kunihiko was a boy he was involved in the running of the workshop, and he would go to buy paper and inks after school. It was a way of relieving students of mundane tasks so that they could fully support the master. He particularly liked delivering fabrics to the embroiderers. "I discovered a different, impeccably clean world. There was no paint, no water, the fabrics and colored threads were beautiful. I took my time looking around: one woman used steam to recondition lengths of fabric. Another handed around tea and biscuits. I was part of the system. That's where my initiation began. My first contact with *yuzen*, the dyeing technique, was in my own family; it was life itself."

After school he spent most of his time in the workshop, watching the students and trainees busying around his father, studying his every move, his hands as they performed feats of precision, and then the result, weeks later, when the wholesaler came to pick up the painted kimonos hung on display stands. "I spent a lot of time watching, and

that was useful later because I already knew everything I had to do, it was all filmed inside my head when I was little. I loved what my father did; it was very original and so different from the others."

Around the time he turned twelve, Kunihiko felt uncomfortable when a student of his father's, who was only a little older than he was, came to live with them and was soon joined by two others. According to the old school to which his father adhered, being a student meant not merely learning a craft, but living full-time with the master, cleaning the house, carrying out all sorts of thankless chores for the family, keeping quiet and obeying orders. "We all lived, ate, worked, and slept together; there was no respite." The young Kunihiko could not bear the discrimination toward the students. "In the mornings I went off to school while they cleaned the house. In Japan you clean even when it's not dirty, to be sure that it can't be dirty. Then they would have a bowl of rice and some soup with the maid in the kitchen. The craftsmen who worked with my father would arrive, and the students had to bring them hot tea. Being an apprentice meant being a slave. They had no time to themselves and they weren't paid. Very gradually they were allowed to contribute to working on the kimonos. Then they would be made responsible for one detail. Next, they would have their own table and could train themselves up. After five years, with a lot of luck and ingenuity, an apprentice might be given an opportunity to make a piece of his own."

Unable to talk openly to his father about what disturbed him, Kuni resigned himself to accepting the situation. "The apprentices didn't eat the same food as us. They worked the whole time. We weren't equals, and it bothered me. Some families I went to were far more democratic and treated their students well. That was what I wanted. But my father was very conservative; he couldn't change."

The only way out for Kunihiko was to leave home as soon as possible. He was very aware that his inclinations reflected a rejection of a tradition incarnated by his father. This resentment was compounded by other aspects of the traditional way of life that he found difficult to bear and deemed archaic. The way the toilets were cleaned, for example: twice a month, peasant farmers would deliver fruit and vegetables to the family; in exchange, they emptied the cesspit and used its contents as natural fertilizer. Kunihiko remembered the blue handcart with wooden barrels tied onto it, and the farmhands emptying the pit with big ladles. The smell this produced was so unbearable that he felt ashamed. The war had left scars that made everyday life difficult. Kunihiko saw poverty and resignation in the people around him, and felt little hope.

After the war, Kyoto's city hall—along with its teachers' unions—was handed over to the communists. Moriguchi's parents wanted their children to go on to higher education. Having been persuaded that public schools were worthless, they enrolled their children at a private Protestant high

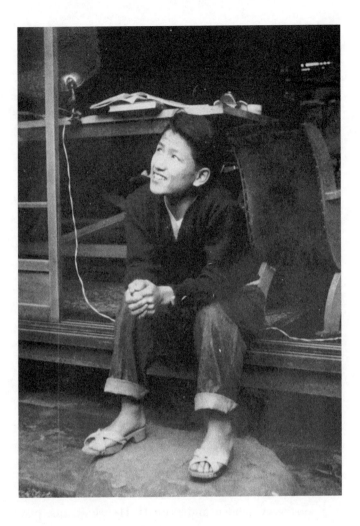

Kuni at age eighteen

school. When Kunihiko was fifteen, he announced that he wanted to be a painter. To help Kuni prepare for a course of study in fine art, Kakō entrusted him to a renowned painter, Inshō Dōmoto. Dōmoto chose one of his students, Yō Ichikawa, to help with the entrance exams for the Kyoto school of fine art. "Yō Ichikawa taught me to look, and to be inquisitive. Thanks to him, I discovered a raw, primitive sort of art and pieces created by disabled people. He influenced me a great deal. We used to go traveling to paint landscapes. We'd be gone two weeks. We didn't have much to eat and slept wherever we could, but I could finally get away from my parents' home and paint, spending the whole day drawing what was in front of me: poppies, trees, and insects."

In 1959, he joined the department of modern painting in the Japanese tradition at the Kyoto City University of Arts, where teachers and students alike were dazzled by American Pop Art: Roy Lichtenstein, Robert Rauschenberg, and Jasper Johns were his models to follow. Unlike his fellow students, Kuni distanced himself from this avant-garde movement—but not before taking part in some experiments in body art: "My own world is probably very pop, but at the time I rejected American Pop Art; I thought it was too heavy-handed and primal." He would not play an active role in the protest movement against the Treaty of Mutual Cooperation and Security between the United States and Japan, a movement that threw universities into chaos in the 1960s. The images that stay with him from

the demonstrations he did attend are of the students' long, sharpened bamboo poles pointed at the policemen's shields, and the violence of these confrontations. His heart was with the left, but he was wary of communists. His parents did not approve of his supporting these demonstrations. A craftsman's son should not put up resistance or oppose society, because this can harm the family and the profession. To express his helplessness and mood of resistance as an artist, he painted a large, dark, tormented depiction of tree roots and a tree trunk surrounded by swirls of dark red. His teachers passed judgment: "You must not express your personal problems in your art. The individual is inconsequential. Art is on a higher plane."

In the fall of 1959, Kyoto's municipal museum organized an exhibition of French art, featuring mostly works from the Louvre. Kuni was intuitively drawn to the Barbizon school and to Corot in particular, his dark houses and landscapes suffused with elegance and serenity: "I was happy to discover that there was a country where nature itself provided answers to the questions we were exploring." This exhibition was a revelation, and by the time he emerged from it, he had decided to learn French: he went straight to enroll in the winter course at the Franco-Japanese Institute in Kansai. "The first thing I remember about setting foot in the Institute was the smell of the director's pipe tobacco. Along with the smell of coal-fired heating, at a time when the Japanese had only braziers. And the women smelled good too; their perfume had a dizzying effect on the young

man I was then." Wafts of pipe smoke, lingering perfume, and constant warmth—these were the dominant impressions from his first contact with French culture. He saw the Institute as an almost maternal refuge that gave him security, warmth, contentment, and comfort, in contrast with the hardships and the cold of daily life at home, where activity in the workshop took priority over the family's comfort.

Kuni's busy timetable during his university years gave him an excuse to get away from home. He divided his time between lectures at university and evening French lessons, and would go home as late as possible when everyone was already in bed. Then he would lie on his tatami and dream of living in France. After a few months, his French teacher, Jean-Pierre Hauchecorne, had been charmed by Kuni's personality and suggested he apply for a student grant from the French government. Kuni's parents then met Hauchecorne, who took a passionate interest in Kakō's work and became a friend of the Moriguchi family. "He put together my application for the grant and arranged my references. He was a cheerful, open person who liked to sing after his classes. We drank tea together and watched films. He was like a godfather to me."

Jean-Pierre Hauchecorne was a warm, cultured man who loved Japan. As a great enthusiast of Mingei art, he collected pieces by the potter Kanjirō Kawai, preferring the plainer, more solid objects with no enamel. Kuni was fascinated by his pretty Japanese house at the foot of the

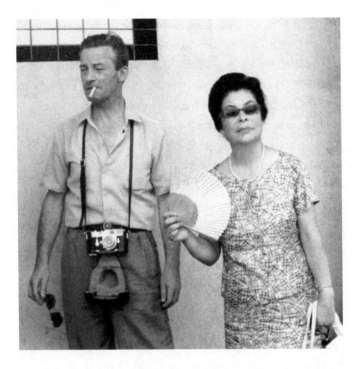

Jean-Pierre Hauchecorne and his wife, Hariette, on the dock
in Kobe Harbor on August 16, 1963, the day Moriguchi left

mountains to the north of Kyoto. The living rooms were covered with carpets and full of countless antique ornaments and Japanese paintings. It was here that he first tasted French food, made by an aging navy cook who worked for the household. Hauchecorne's father was consul general in Osaka and Kobe. Jean-Pierre had come to Japan to visit his father when he was eighteen, and had stayed. He had secured a job at the French Institute, but, because he had no qualifications, his career went nowhere. His sheer likability, however, meant that this did not stop him escorting Nicolas Bouvier and many other artists and political figures on trips to Japan.

Thanks to his support, Kuni secured a one-year grant at the École des Arts Décoratifs in Paris, thereby realizing his fondest wish. He could finally live as himself, far from family constraints and the traditions of Japanese society, and could reveal the artist in him. "I wanted my Japanese sensibilities to explode all over the world like a bomb."

TRAVEL

IN AUGUST 1963, freshly graduated from the Kyoto City University of Arts, the young Moriguchi set sail on the liner *Le Cambodge* (the *Cambodia*), which was to take him to France. "The day I left, August 16, was Daimonji. That's the day at the end of O-bon season when fires are lit in the mountains, so that the souls of dead ancestors can return to the spirit world. It's a ceremony that dates back to the thirteenth century: all the hills around Kyoto are ablaze for half an hour. I couldn't be there; I left along with my ancestors."

On the dock in Kobe Harbor everyone was there to wish him good luck and bon voyage — relations, teachers, friends, and his father's students. His thoughts were particularly with the youngest student, who had stayed in Kyoto to watch the house. The departure itself was a celebration,

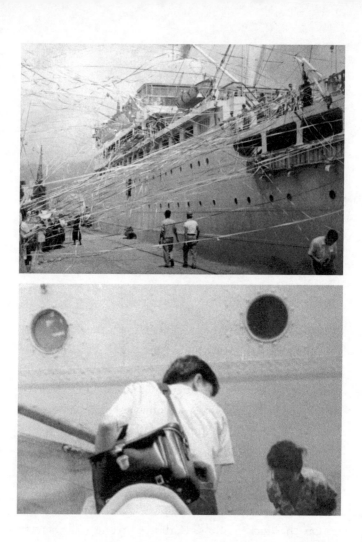

Kunihiko Moriguchi in Kobe, 1963

with colorful garlands thrown from the upper deck and a concert of sirens, foghorns, and whistles.

The crossing was long and a whole new experience, starting with the boat itself, whose passengers included rich vacationers on a cruise in first class. Kuni watched them lounge on deck chairs. A pretty girl in a bikini strolling about with a baby leopard fascinated him. "It was just like my dreams: there were tall, elegant blonde women with endless free time. I was completely captivated. Along with those images, I remember a Sylvie Vartan song, 'Dancing Party,' coming from the loudspeakers by the swimming pool."

A gray-haired Kunihiko sitting opposite me with his milky coffee frankly described this twenty-two-year-old Kunihiko, with his tousled black hair, discovering an unsuspected world of freedom beyond dark, isolated, backward-looking Kyoto. He watched the sea for hours, leaning on the rail and hoping to see a dolphin, a whale, or a migratory bird. In Hong Kong, wanting to fly a kite, he chose a high-rise building at random, climbed to the top floor, and launched the kite into the wind. He stayed there a long time, his head tipped toward the sky. "I love kites because, with the force of the wind, you can touch the sky and establish contact with it. Whenever I see somewhere high, I get out my kite."

Saigon was at war and under curfew, but nothing frightened Kuni. During the day he visited museums guarded by American tanks and troops. What he longed for, though,

was to explore the city by night, even if that meant defying the law. The gangway had been pulled up. "There was still a small doorway down on the quay for the French sailors. I made friends with one of them, and we went out for a drink one evening in a taxi he'd booked. We went to a 'pleasure district,' where there was a sort of exuberance. I had fun in Saigon even though there was a war on."

The stopovers continued: Singapore, Colombo, Bombay…and an engine failure in the middle of the Indian Ocean. In Suez, a trip to Egypt to see the pyramids. Then Marseilles and the train to Paris.

◆ ◆ ◆

HE HAD BEEN ALLOCATED a room in the Japanese house on the university campus, but the thought of being surrounded by Japanese depressed him, so he swapped it for a larger room on the top floor of the Spanish house. Still keen to introduce his new French and international friends to Japanese culture, he invited them to take part in a tea ceremony, having learned the ritual before leaving Kyoto as a way of keeping his bearings, a reference point, to avoid feeling completely uprooted.

His first impressions of Paris were disappointing: "I thought Paris gloomy and dark. It rained a lot. In fact, the first words I learned were 'shit weather.' The sky was permanently overcast and I didn't see the sun for three months! I was struck by a picture in *Le Figaro*: it was of a penguin on a

chunk of ice drifting up the Seine near Notre-Dame." The red tape at the administrative offices consummated his disillusionment: "You had to stand in line to get a number so you could stand in line again until the next morning, and every form meant waiting just as long. Not to mention the office workers who were always grouchy and busier smoking cigarettes than doing their work."

Kunihiko came close to succumbing to "Paris syndrome," which affects some Japanese devastated by the chasm between the reality they find and their idealized imaginings. Had he lost a bird in the hand for the sake of two in the bush when he left Kyoto?

DECORATIVE ARTS

MORIGUCHI'S TIME at the École des Arts Décoratifs in 1963 started with three days of nonstop hazing of new students. Luckily, he was enrolling in the second year and so was not directly affected. "I would have died of shame if I'd been subjected to that sort of ordeal," he confided to me. Francis Metzler, who came from Grenoble and joined the school at the same time as Kuni, has vivid memories of those times and of the Japanese oddity who has remained a close friend to this day: "The hazing was absolutely unbelievable — so loud and aggressive! The brass band played the whole time, repeating pieces, always the same ones. Playing harmoniously was definitely not the aim. They had to make noise, stir things up, and everyone joined in the chorus of slightly risqué songs. The queen of hazing was called Françoise Taureau. She perched on top of some cupboards with her

retinue around her, and sat there knitting as she issued orders. The idea was to have a laugh, but in a French way. Everybody laughed, newcomers as well as old hands. You might be treated to glue, feathers, paint. Everybody milled around, sang songs, told nonsense stories; it was the ship of fools! Those who wanted to stripped naked. It was so slippery that, whether or not you had clothes on, everybody ended up on the floor, covered in paint and feathers."

It is not hard to imagine the effect this had on Kuni, who was used to his father's silent, industrious, civilized workshop; the calm, hushed order at the Kyoto City University of Arts; and codified social exchanges. He remembers some students leaving, unable to cope with the frenzy and stress of this hazing. Most of those I have met describe a fairly good-natured atmosphere.

Kuni, meanwhile, had decided to go the distance come what may. He had been selected for this grant. He was in France, his course was paid for, so he must succeed, he had no choice. He owed it to himself to make a success of this in order to honor everyone who had believed in him and supported him, starting with his family. But moving into this new world took a huge amount of adapting.

◆ ◆ ◆

MORIGUCHI GAUGED the gulf between the Japanese and French mentalities. Japanese culture evolved under influences from Buddhism, Confucianism, and Shintoism.

These are polytheistic religions that do not entertain the notion of a single, all-powerful god nor even of transcendence. "These religions," Etsuo Yoneyama tells us, "did not operate in Japan's history in such a way as to develop a universal mode of thought or a concept of abstraction as we see in cultures with monotheistic religions. Neither did their influence favor self-assertion or the notion of an individual's rights. They did, however, foster the development of community spirit and harmony, and a sense of pragmatism." According to Yoneyama, the monotheistic world is based on the notion of a transcendent god who subjects humans to a dogma based on original sin and the fall of man, while humans in turn have power over the natural world. The pyramid works from the top down. By contrast, gods in a polytheistic world are ill-defined, unranked, and not associated with any dogma. The natural world is placed above humans in the pyramid, and gives access to the gods at the top of the pyramid. Humans are connected to one another by trust and regulated by self-respect, respect for others, honor, and the fear of "losing face."

◆ ◆ ◆

IN THE EARLY DAYS, Kunihiko had trouble following his classes. The lecturers spoke quickly and seemed unconcerned about being understood. Other students messed around while they worked, but Kuni was always very serious, speaking little, in rather poor French — or perhaps he was too shy to speak more freely. Metzler told me that,

although Kuni struggled to express himself, he was intent on an exchange of ideas with other people. "We spoke a lot of slang at the school. He always had his dictionary with him and looked up every word. I was impressed by this need to understand, compared to the hurly-burly herd in the studio." His friends from this period describe him as an almost unobtrusive young man, well dressed but very discreet. He did not wear jeans or colorful shirts, but simple, classic clothes. Metzler saw Moriguchi as a Cartesian striving to understand what was going on in a place of constant, overriding mayhem: "At first he asked me a lot of questions. We'd identified each other as outsiders in that manic world. And it was probably natural that we came to help and support each other." The fifteen newcomers adapted to life with the forty-five existing students with whom they shared a studio: "That studio was our life, it was our family. We often slept there and we ate there. We met people and helped each other while serving as gofers to the more senior students. It was in that studio that we learned to live and talk…and to keep our mouths shut, too. Most importantly, we learned a lot from watching others work."

From the first practical exercises, Moriguchi stood apart from the others: his absolute calm, his great mastery and endless patience. He impressed his fellow students as well as his teachers. But he admits that some classes were very hard. "The perspectives instructor was really strict. I spent so much time on his classes! At the end of the year we had a public interview as part of the exam; the amphitheater

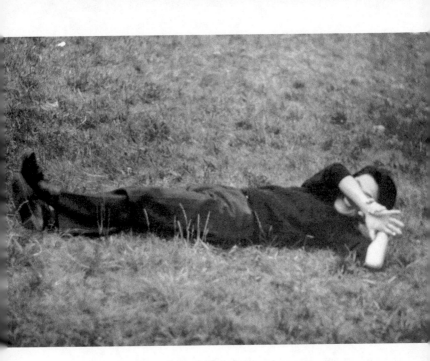

Kunihiko Moriguchi on campus, 1964

was full. We were asked about sixty questions and we had to do a drawing for each situation. The numbers were allocated at random. The person being asked the question had to draw their answer up on a stage in front of the whole amphitheater, explaining as they went along. It was very hard, but it was my subject and I could sometimes help the others. Some were jealous that I was better than they were, even though I was Japanese."

From Monday to Saturday, mornings were devoted to charcoal drawings, copies of works in the Louvre, or clay models of the human form. Failing to submit work each month could disqualify you from continuing to the next level: Kuni found this rigorous teaching system very stimulating. The plaster statue modeling classes were extremely tough, but this training would later be very useful to him when he came to consider the three-dimensional nature of *yuzen* kimonos, even though he had no such thoughts at the time.

For his fourth-year specialization he chose graphic design, a newly created discipline at the school. The director, Jacques Adnet, brought in graphic designers from the Swiss school, which was very much in vogue at the time: Jean Widmer, the natural heir to the Bauhaus tradition, and Adrian Frutiger, the groundbreaking typeface designer whose work was adopted by IBM. Jean Widmer liked the optic art that was just emerging in France. He trained his students using exercises in gradation. On sheets of paper

fifty centimeters square they had to draw about one hundred parallel lines with a ruling pen, spacing them progressively farther apart. Metzler remembers this as an ordeal: "Two girls groaned and said, 'I can't do it, I can't do it!' and I felt the same. The only person who could draw those lines reliably, firmly, and regularly was Kuni, and I asked him how he could concentrate so hard. He said, 'It's all in the breathing. You hold your breath and work without breathing.' He was doing it by holding his breath."

Without knowing it, I had used the same technique as Kuni when filming over his shoulder while he traced the outline of a pattern onto kimono silk. He had probably held his breath at the same time as me.

Kuni worked until midnight every evening at art school, going over everything they had done during the day. One of his fellow students, Philippe Weisbecker, wanted to find out more: "He intrigued me; the work he handed in was so perfect. He invited me to the campus one day and told me that every morning he hunkered down, holding a long stick with a pencil on the end, and spent fifteen minutes drawing parallel lines as straight as possible. He wanted to achieve perfection. It was a Zen-like pursuit."

Kuni reproduced what he had seen done in his father's workshop, with the same rigor and the same high standards, both in drawing and in colorwork.

"It was the beginning of pop," Metzler also told me. "We listened to the radio. Our colorful world was full-on, it pounded. But Kuni managed to come out with ten different

greens in one palette. Neither I nor any of the others had the same chromatic sensitivity. It was beyond us. With our assessed work, we threw ourselves at it and were happy to finish. With him it was the other way around, and where we spent ten minutes, he'd take three hours. Every angle was perfect, as Widmer had taught us: when you draw a right angle, the point needs to stand out so that the eye can trace the perfect angle. Kuni immediately implemented everything we were taught. He taught me to take things slowly, to be consistent, and to value a job well done. You don't cheat; there's always plenty of time, and you work calmly right up to the last second."

How did the young Moriguchi experience being so far from his family and his country? Metzler remembers him occasionally talking about Japan. Every ten days he received a letter from his mother with news of the family and the workshop. His mother sent him parcels of little cakes, nibbles, and puffed rice, and he shared them with Metzler. "I still have the tins of green tea he gave me. I used to joke, saying it tasted like grass. Everything he gave me was like treasure that I hoarded. I knew that it was a concentrate of know-how and quality."

Metzler thinks that Kuni threw himself so headlong into his work because he felt exiled. While Metzler had left home to establish his independence, he could see that Kuni was still very attached to his family, despite or perhaps because of the distance. He had a number of Japanese friends in

Paris, such as the filmmaker Kôichi Okamura, who was awarded the same grant as him. He also saw people on campus, but he seemed to have few real friends. Metzler was his main family. "When I went on vacation, he came to my parents' house with me. In the Savoie region, or elsewhere. Sometimes he would disappear for a week or ten days. No one really knew where he went, but he was happy to come back."

The quality of Moriguchi's work met with approval from his teachers, and in 1965, Jean Widmer summoned him to his agency to ask him to design a Christmas card for the review *Jardin des modes*, a magazine that was then very important in graphics and for which Widmer had created a strong visual identity. "It was a real responsibility, because it needed to express an image of Widmer and his creations to his clients and friends. So it had to be original and show good taste." Encouraged by this first commission from someone he respected and whose work he admired, Kuni could see himself leaving art school with a secure future in the country of his choice, where he now felt settled. Leaving aside his extraordinary politeness, which was distinctly Japanese, he had as good as become French.

When his course finished in 1966, Kuni was recognized as one of the top students, and everyone expected great things of him. "I was convinced Kuni would stay in France," Metzler told me, "that he would settle here. All the big agencies and architectural studios, in both graphics and publishing,

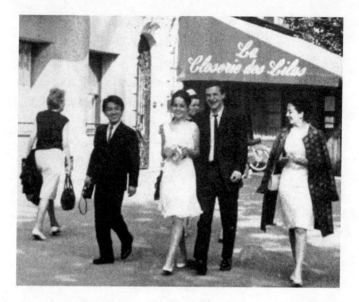

Kunihiko in Paris with art school friends, 1966

they all wooed him." The colorist-designer Jean-Philippe Lenclos was equally sanguine about his prospects: "Kuni could have opened a design office in Japan, a country where graphic design wasn't particularly well developed. Ikkō Tanaka was one of the greatest graphic designers of his day, and Kuni could have taken over from him." Philippe Weisbecker could also see him setting up as an architect or a graphic designer somewhere in Europe.

But Kunihiko Moriguchi did not settle in France. Shortly after graduating, he went to find Metzler to tell him he was returning to Japan for good, to set himself up in the workshop and learn the *yuzen* technique from scratch, so that he could follow in his father's footsteps. Metzler objected, saying that Kuni had a golden future in France; it would be foolish to leave after all the work he had put in, and walk away from the professionals who were rolling out the red carpet for him. Metzler remembers his own disbelief when he heard there was also talk of a "girl" in Japan, that Kuni was returning to be married: "'But, Kuni,' I said, 'you can't be going back to Japan to get married! Do you know this girl?' He didn't really know her. I asked him why he was doing it and he replied, 'It's written in gold letters inside my head.' In 1964 — we were twenty, twenty-two — if someone tells you something like that, you don't forget it…I thought he'd gone completely mad or plain dumb."

This insistence from Metzler and other art school friends that he should stay in France did succeed in weakening Kuni's resolve. He decided to take some time to think.

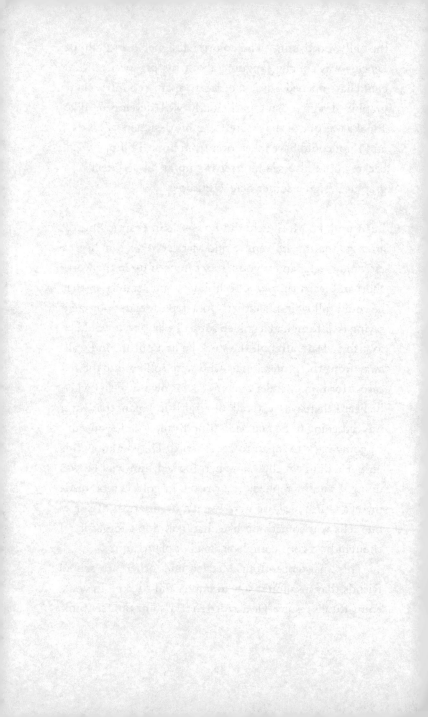

DOUBLE LIFE

WHEN KUNIHIKO sailed to France on board *Le Cambodge* he could never have guessed that, on that liner, he would meet someone who would give a whole different dimension to his time in Paris. Out at sea several weeks after leaving Kobe, one of the headwaiters had brought him a message from a passenger in first class inviting him to lunch. Ryōun Kaneko, a great specialist in Heian period Buddhist sculpture, was traveling with Yuwao Murai, an expert in third-century Haniwa funeral pottery. Moriguchi the elder, who knew both men, had mentioned to Kunihiko that they would be on board, but he had been in a hurry to forget the fact, having little enthusiasm to travel with people from the traditional world he was fleeing. The episode felt insignificant to Kunihiko, who saw this invitation as a simple

courtesy to his father and was convinced he had nothing to offer them, nor they him.

These two conservators from the Tokyo National Museum were on *Le Cambodge* to escort precious crates of antique Japanese artworks that were to be exhibited at the Petit Palais in Paris. In December 1958, André Malraux, minister of culture under General de Gaulle, had traveled to Japan and floated the idea of an exhibition in Paris. "This is not simply a question of a Japanese exhibition but an opportunity for two age-old civilizations to meet," he had told journalists. The idea was to showcase the sacred aspect of both cultures. He had entrusted the running of this exhibition to his friend Balthus. Five years later the exhibition was to be realized in France.

Shortly after arriving in Hong Kong, the conservators found they were unable to draft a telegram in French and asked Kunihiko for his help, promising in return to invite him to the exhibition at the Petit Palais.

After enrolling at the École des Arts Décoratifs, Moriguchi had started to find his bearings in the French capital. It was at this point that the two conservators, panicking because the installation process was behind schedule, called him: only a few weeks before the exhibition was due to open, nothing was ready. In Japan museums usually entrusted the installation to a designer who handled everything. But that was not how it worked in France. The museum had offered them the services of an elderly carpenter with whom they had difficulty communicating, unsure what

color wallpaper to use or what height to make the pedestals. Kuni was happy to put into practice his knowledge of Japanese art history and his talents as a designer, and to speak to a Frenchman in French. He quickly became friends with the old carpenter — I imagine the man reminded Kuni of craftsmen in his own country — and they worked on the installation together. Until the day when Moriguchi disagreed with something that had already been decided. He thought it would be appropriate to put Hasegawa Tōhaku's painting (which, in his view, was one of the standout pieces in the exhibition) where it would be most visible. The work demonstrated the emergence of Japanese painting, breaking away from Chinese influences. In this particular spot, however, the entire wall had already been covered with rolls of Zen works — humorous images, in fact — painted by monks. Moriguchi vented his indignation to the conservator Kaneko: "The person who gave the instructions for the installation is making fun of Japanese art; I'd like to speak to him." Kaneko tilted his chin toward a man whom Kunihiko had seen over the last few days: it was the exhibition's curator — who had very entrenched ideas on Japanese art. Kunihiko was warned that this man was not to be contradicted, unless he wanted to unleash his fury.

He was a tall, slim, elegant man with a cane, like a dandy. Wearing Camargue pants and a green cotton shirt, in one hand he held an Italian peasant's red and blue handkerchief. A whole palette. He spoke to Kuni with a slightly theatrical courtesy that surprised the young student: "What

would you like to be in life, young man? A designer?" But Kuni was not there to discuss design. He wanted to challenge a decision and explain the validity of his objections. "I spoke very politely, very slowly, and he did too. He spoke slowly because as a boy, he'd had a stammer, so I understood every word he said. He invited me to lunch and arranged to meet me an hour later at the restaurant Lipp. Then he introduced himself. He was Balthus."

◆ ◆ ◆

"WHEN I MET UP with him at the restaurant, he was wearing a dark blue suit and a white shirt. Such elegance! Beside him, I was just a miserable little Japanese boy. The lunch went on until late in the afternoon. He listened while I talked about Japanese art, but he knew more on the subject than I did, even though I had learned about it from one of the greatest connoisseurs in Japan. I was sure of myself and I dug in my heels. I felt that Hasegawa Tōhaku was a profoundly Japanese painter. Balthus saw Chinese influence in his work. He justified his choice of what to hang where by explaining that it was the first time since the end of the Second World War that antique Japanese works of art had been exhibited to the Parisian public, and he was keen that the French should not confuse Chinese art with Japanese art. He wanted people to be aware of and receptive to Japanese originality."

Even at his young age, Kuni was touched by the interest Balthus showed in Japanese culture: "What a character! I

thought to myself. And he'd hung the paintings so that they formed the ideogram *kokoro*, which means 'heart' or 'feelings.' I thought it a very generous idea. I accepted everything after that."

The exhibition was organized by the Tokyo National Museum, the newspaper *Asahi Shinbun*, the minister for cultural affairs, and the foreign minister. It was called "The Hereafter in Japanese Art" and was held at the Petit Palais between October and December 1963.

In 1962, Balthus had been invited to Japan by the daily paper *Asahi* to select the exhibits. As was customary with a high-ranking foreigner, the newspaper had put at his disposal a pretty young woman of eighteen, Setsuko Ideta. Coming as she did from a middle-class family (her father ran Esso Japan), she spoke a little French. Balthus had fallen under her spell and arranged for her to come to Paris. They lived together until his death.

The weekend after Balthus and Kuni met, Balthus took the young Japanese student to the Chateau de Chassy in the Morvan region, where he had previously spent seven years, isolated in the countryside with his young cousin by marriage Frédérique Tison; she had been his lover and model. "They told each other stories that no one understood. They had a sort of collusion full of word games, a world of their own. I liked seeing them like that—so natural." In 1961, after the couple separated, Balthus had given the chateau to Frédérique and gone to live in Rome at the French Academy, where he had been appointed director. During the

preparations for the exhibition at the Petit Palais, he lived with the Picons in the Gobelins neighborhood, and Kuni went there very often after his classes, forsaking his studio in the cour de Rohan. Gaëtan Picon was an art critic and director-general of arts and letters in Malraux's Ministry of Culture. Won over by Kuni's charm, intelligence, and kindness, Gaëtan and his wife, Geneviève, took him under their wing and introduced him to everyone who was anyone in Paris at the time. Which is how he rubbed shoulders with Miró, Max Ernst, Chagall, Masson, Jacques Prévert, and the Giacometti brothers; and how he attended dinners held by Carmen Baron, who hosted people from the worlds of theater, music, art, and literature at her salon at 54, rue de Varenne, opposite the Hotel Matignon. He never told his art school friends what he did at the weekend or when he slipped away during vacations. He was extremely discreet and lived a sort of double life with perfect peace of mind. His artistic nature, critical acuity, and enthusiasm for communication probably blossomed thanks to his contact with these great artists and intellectuals. In the space of three years, Kunihiko had gone on an extraordinary, serendipitous journey for the young son of a Japanese craftsman who had grown up in Kyoto's Nijō neighborhood. He knew this and never tried to hide his origins.

When he graduated in 1966, Moriguchi needed a guarantor in order to prolong his stay in France. Balthus, who was then running the Villa Medici in Rome, became his guarantor and enthusiastically invited him to come and join him

in the Roman sunshine to think about his future with a clear head. He would stay for more than five months.

Balthus had returned to Japan in 1964 to oversee the return of the works exhibited in Paris. Accompanied by Setsuko and Jean-Pierre Hauchecorne, he had visited Kunihiko's father, Kakō, and discovered his painted kimonos. He had been fascinated by the quality of Kakō's work and the harmony of his colors, and they had struck up a rapport as fellow artists. Setsuko remembers their meeting: "Balthus was spellbound. He had great respect for Kakō and listened to his explanations, how he'd invented particular dyeing treatments. Balthus studied everything very closely and attentively. He said it was a great stroke of luck that Kuni should be the son of this brilliant artist. Kakō showed Balthus the studio and the technique for creating what's called a *makinori* effect on fabric, and it was spellbinding because Balthus didn't like solid colors. *Makinori* created resonances that corresponded with Balthus's experimentations in pictures."

Did the two men discuss Kuni's future? Jean-Pierre Hauchecorne appears to have been in favor of his returning to Japan. How could Kuni find the strength to realize all his hopes in France if everyone had other plans for him?

◆ ◆ ◆

KUNIHIKO STAYED in the Turkish Room at the Villa Medici. The room is at the top of one of the towers and was designed

by Horace Vernet in the nineteenth century, in homage to the myth of travel in the East. It is a square room with two windows, through which there are views of the Roman countryside in the distance. The walls, ceiling, and floor are tiled throughout in Middle Easter–influenced designs. "I would lie down on the banquette, tip my head back, and for a long time I'd look through the window, watching the abstract, random flight patterns of starlings in the azure sky." It is impossible not to think of Balthus's painting *The Turkish Room*, completed in 1966 when Moriguchi was at the Villa Medici. It represents Setsuko sitting naked on a bed like an Ingres odalisque, surrounded by geometric patterns on fabric, wallpaper, and tiles with geometric designs. There is no perspective; objects and furniture are depicted two-dimensionally. The shutters are closed. Kuni would use some of the patterns in this painting as the basis for his geometric sequences.

Life at the villa was delectable. Kunihiko was a member of the family and learned to adopt the idleness imposed by Balthus in order fully to experience the pleasure of the moment without thinking about anything. He joined in festivities with Balthus's friends and visiting celebrities. He was invited to dinner several times by Fellini and Giulietta Masina, went to Ferrare with Tony Curtis in his convertible, traveled around Tuscany by bus to explore the region's museums, and discovered a passion for Piero della Francesca.

◆ ◆ ◆

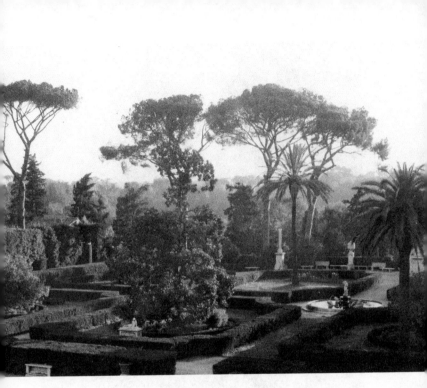

Garden at the Villa Medici

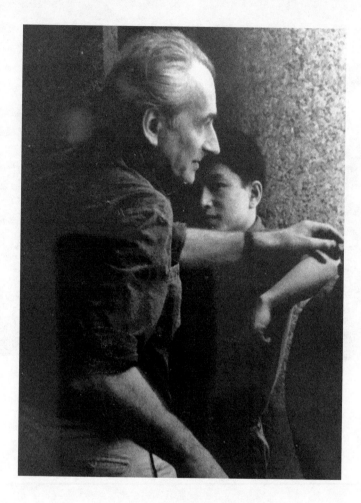

Balthus and Kunihiko at the Villa Medici, 1965

DINNERS ALONE with the artist mostly ended up over a glass of cognac in the library. Balthus took books off the shelves, explained the origins of his painting, and listed the painters to whom he felt he was indebted: Piero della Francesca for his clarity, Poussin for his classicism, Courbet for his realism. He liked Maurice Denis's symbolism and nineteenth-century illustrations for children. Balthus saw painting as Art with a capital *A*, something serious, a profession, an ethos. In Balthus, who was glorified by Malraux's respect for him, Kuni saw an artist who did not cut corners. This Zen approach to work reminded him of his father, and it was perhaps while he was in Rome that he came to understand who Kakō was artistically. Balthus told him how important it was that skills were passed from generation to generation, and he regretted that this tradition was being lost in France. At this point he slipped into the conversation: "Painting kimonos is a fine career; you could consider it."

Balthus had applied for a study grant from the Ministry of Foreign Affairs for Setsuko so that she could be at the Villa Medici on an official footing, because she was only twenty years old and they were not yet married. Kuni, who was around the same age and found he was equally redundant at the villa, threw himself into a book project with her. "I couldn't hang about doing nothing, so I suggested to Balthus that we could make a book about his collection of Japanese *do-ningyō* dolls. These earthenware figures fired at

very low temperatures are really popular in Japan. I would take black-and-white photos of them and Setsuko would write the text. Balthus encouraged me and found a publisher for us. I started taking the pictures, set-dressing the dolls in natural surroundings or with architectural backdrops. I developed the prints myself, but the publisher said my proofs were too dark and I gave up."

◆ ◆ ◆

WHY DID BALTHUS take an interest in "the excellent Moriguchi," as he called him? Of course, the young man had every good quality in the world, and I have already mentioned them, but there is still an element of mystery in this relationship. His friends from that period have put forward the theory that, to Balthus, Kuni embodied the myth of Japanese art and culture that so fascinated him. But Setsuko reminds us what an integral part of Balthus's life Japan was: "We mustn't forget that as a child he was close to Rilke, who was his mother's lover, and close to André Gide, who introduced him to Noh theater from an early age. His brother, Pierre Kossowski, was André Gide's secretary and was interested in poetry and haikus."

Balthus was introduced to this raft of Japanese culture when he was very young. He was drawn to Shinto and Buddhist thought. When he was eleven, he found and then lost a cat that he had named Mitsou, a Japanese-sounding

name that would later be the title of an illustrated book of his drawings, with a preface by Rilke. His meeting with Setsuko, and then Kunihiko, most likely chimed with his childhood memories. They each became part of his life: Setsuko the muse and lover, Kunihiko the friend and first-hand witness to an ancient culture incarnated by Kakō with his painted kimonos.

◆ ◆ ◆

BALTHUS HAD BECOME a substitute father for Kuni, and perhaps he was cleverly manipulating him, not taking into account the young man's aspirations and his wish to stay in France. As the days went by, he gently reiterated: "You can stay at the Villa as long as you like, but go home to Japan once and see what's going on. And if there's nothing for you there, you can always come back to Europe; I'll be waiting for you." In the evenings, when there were friends and temporary visitors, conversation often revolved around what history and tradition meant. "We mustn't stop handing down traditions from generation to generation. If possible from father to son, that's the best way."

A few months before Kunihiko left Kyoto for Paris in 1963, his teacher at the French Institute had been Jean-Philippe Lenclos, who had spent two years at the Kyoto City University of Arts and was learning Japanese. When Balthus visited Japan in the planning stages of the Petit Palais exhibition, Lenclos had been asked by the French Embassy to

act as his guide around the city along with Setsuko, and he had helped in meetings with Japanese conservators. He had been the first to witness the future husband and wife's meeting and remained a close friend. Kuni would meet up with him at the Villa Medici during vacations, because, like him, Lenclos was part of the family. When Malraux gave Balthus carte blanche to restore the Villa Medici, which had been as good as abandoned, the artist had asked Lenclos to think about a new color for the façade, which was white at the time. Kuni contributed to the research and watched Balthus at work. Drawing on his experience from his father's workshop, he learned from watching and trusting in his artistic intuitions.

◆ ◆ ◆

"THE FLOORS in the Villa Medici," Setsuko tells me, "were exactly like those in Renaissance villas, made of marble and in a more nineteenth-century style. Balthus had everything taken up and replaced with handmade terra-cotta. The gilding on the wall friezes had to be removed and replaced with *shibui*-style patination. In Kuni's eyes and mine, *shibui* was supremely beautiful. Without talking or explaining, Balthus demonstrated very assured principles of beauty: the sensation produced by a simple, effective, subtle, and discreet kind of beauty. It was wonderful for us to see that a great painter, chosen by Malraux, could reproduce in France [or Italy] something we thought glorious in Japan."

Setsuko was descended from a Samurai and grew up in Tokyo at a time and in an environment where Japan was embracing a Western model. She learned the piano and classical dance, and was not part of the traditional world that still existed in Kyoto. It was through her conversations with Kuni and her life with Balthus that she rediscovered her culture's roots. Since then, she has taken to wearing kimonos in her day-to-day life: "Wearing a kimono identifies me, reinforces me as who I am and where I come from. Being enveloped in that craftsmanship gives me back a sense of being Japanese and being in harmony with my country's spiritual values."

Was Balthus aware of a similar longing for Japan in Kuni? "When you come from a country that you have the opportunity to return to, you go back," he told him. He may well have been expressing his own nostalgia: as a Polish aristocrat, he could not return to his country now that it was communist. "Your country has an age-old culture, and you should connect with it rather than try to run away from it. You should go back to Japan."

According to Setsuko, Balthus said that Kuni must not stay in Paris. He was afraid he would get lost in contemporary art or become an eternal student. He had to go home. Kuni's path was to some extent determined at the Villa Medici. "The things he said made me reconsider everything I had built up to escape my father's world. And this was coming from Balthus, a great artist who valued tradition

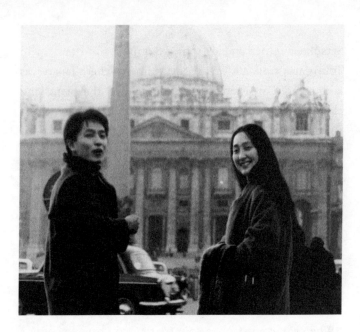

Kunihiko and Setsuko in Rome, 1966

and was a success! He completely took me apart…and probably put me back together again."

<p style="text-align:center">◆ ◆ ◆</p>

ON DECEMBER 15, 1966, Balthus and Setsuko left the Villa Medici to spend the holidays in Geneva. Kuni went to the airport with them, and on the drive back he confided in Luigi, the chauffeur and right-hand man at the villa. He had made up his mind to go home and live in Japan. He wanted to leave while Balthus was away, without informing him, to avoid a big goodbye. Distressed that he could not thank Balthus adequately, he left two Japanese paper umbrellas and a drawing on fabric at the villa.

When he stopped off in Paris, Kuni did not want to disturb anyone. On his last evening, he remembers eating sauerkraut, alone, in a restaurant on the rue des Écoles. "It was a rather sad departure because I'd built a life for myself and I had to leave it all."

When he stepped onto the airplane on December 24, the only other passenger was a pretty flight attendant on vacation. The pilot invited them both into the cockpit. As they headed east, they watched the sun rise in a blaze of incandescent light over the curve of the earth.

<p style="text-align:center">◆ ◆ ◆</p>

BALTHUS DIED at the age of ninety-three, on February 18, 2001, the very day that Kuni turned sixty. How not to see this coincidence as a sign of the friendship between them? Kuni went straight to Switzerland. "He was an open man, close to other people. A great man but simple, very rural," Kuni told me when talking of his death. Setsuko saw Balthus as a sort of backbone in Kuni's life: "When I saw Kuni's email address, I noticed that it contained the date that Balthus died: kuni218@. He came to Rossinière for the funeral. He brought his paintbrushes and we threw them into the vault."

BACK TO SQUARE ONE

"**I ARRIVED** back in Japan in December 1966, after three years in France. It was New Year's holiday time, and everyone was very kind and welcoming to me." On January 5, work resumed at Kuni's father's workshop, where there were now six young students and three older employees. Kuni had announced, with a degree of apprehension, that he would follow in his father's footsteps. "Kakō worked relentlessly, and I thought I'd find it very hard working with him."

Kunihiko told me that he had left Japan because he disagreed with the traditional—almost feudal—way his father's workshop operated. How did he feel now about this contradiction? "I really wanted to change, to become an artist. When Balthus urged me to return to Japan, he didn't know that I wanted to see change. I don't even know what he thought of my kimonos after that."

♦ ♦ ♦

BALTHUS'S VISIT to Kakō's workshop in 1962 probably confirmed the idea Balthus had of Kuni. Having been captivated by Kakō's art, he later could not picture Kuni anywhere but in that workshop in Kyoto, and his position as a father figure lent his wishes particular weight. It all seemed to be predestined, and Kuni knew this. He was at first disappointed not to have launched an artistic career in Europe, but eventually accepted his destiny good-naturedly and with a degree of enthusiasm, because he hoped to turn this disappointment into a challenge. He remembered what he had learned from Balthus, who had told him, with reference to his erotic paintings featuring naked young women: "Nowadays you have to shout very loud if you want to be heard." His arrival on the *yuzen* painting scene would need to be made with a radical and provocative artistic flourish. Until the time came for this revolution, his father took him on courtesy visits to wholesalers in Kyoto and Tokyo to celebrate his joining the profession. The director of one wholesale store invited him for a meal at a restaurant in Akasaka whose manager collected Kakō's creations. The wholesaler had arranged for a succession of geishas to appear wearing his kimonos. The drink flowed and it was an animated evening, and Kuni witnessed for the first time the renown that his father enjoyed: "Seeing his style paired with the elegance of geishas, I realized that—beyond the commercial aspect—the kimonos that my father created were first and foremost expressions of inimitable creativity

and audacity. The more official my admission into that world became, the more anxious I felt: I was twenty-six, I hadn't painted a single kimono in my life, and I was officially being introduced as my father's successor."

◆ ◆ ◆

WHILE HE WAS STUDYING in France, Kuni had developed subtle artistic sensibilities and sufficiently assured judgment to know that it would be completely impossible to match his father, because his designs of plum trees, waterfalls, cranes, and chrysanthemums were technically perfect.

After their evening in Akasaka, father and son shared a room at an inn. Lying with his head on the pillow, Kuni ventured to say: "I think your kimonos are magnificent, but if I have to draw the same patterns as you, I might as well stop right now. I need to know if following in your footsteps implies working in the same style as you. I might as well tell you straightaway, I'll never be as good at it as you are."

His father hesitated before replying, "Have you ever seen the work of my master Kason Nakagawa? I was utterly sincere in my support for him while I worked for him, but then when I set up on my own, I broke away completely from his style, and you can do the same. It's your right, your duty even." His father therefore gave him the total freedom that he needed to develop his art while respecting tradition.

Kuni could now feel confident as he told his father about his personal vision of *yuzen* style given a dynamic twist by

Kakō Moriguchi

referencing optic art. He wanted to shift kimonos from the two-dimensional concept of traditional designs to three dimensions — like sculptures — when they were worn, and to a fourth dimension when they were worn in motion. What he was striving for was not so much mastery in the design but rather for the whole kimono to become a design, a sculpture in motion. A revolution in the world of *yuzen*.

When he came home from Tokyo, he started making sketches using compasses and a ruler, working in a small room adjoining the workshop. He spent long days working in there alone. "Kakō called all his students together and told them I would be working alongside them. He asked them to take care of me." Tradition dictated that it was not the father who taught his son but a student, even if that meant a young newcomer. The student was twenty-four and already had seven years' experience; Kuni had no experience at all. He started by drawing lines and geometric shapes based on exercises he had done at art school, but he showed his sketches to no one. "The truth is, I felt I was disturbing them. Every time I asked them something, they had to stop what they were doing to help me. I didn't want that, but at the same time, if I didn't ask any questions, I wouldn't get anywhere. It was very uncomfortable; right from the start, I felt like an outsider. The worst of it was, everyone respected me." The student who was Kuni's assistant waited for his instructions, but Kuni had no idea what to ask of him.

◆ ◆ ◆

KUNIHIKO CALLED his first kimono *Hikari*, which means "light." He took his inspiration from the Op Art that he had studied at art school and that was now appearing in the French fashion industry and haute couture. "Although I didn't have much experience of drawing *yuzen* lines (*itome*), I tried to create my own artistic universe using fundamental *yuzen* techniques. I wanted to train myself to draw but also to experiment, producing progressively smaller graphic elements to explore the relationship between the pattern and the negative spaces. From the start, I was interested in the importance of those spaces."

Kimono means "thing to wear." It is a two-dimensional garment that reveals its three-dimensionality when it is worn. Kuni tried to introduce this criterion in the design of his very first kimono. He had spent months on his own, obstinately developing his idea, and this, it seemed to him, had not been viewed favorably in the workshop. The eldest of his father's students taught him technical skills, and the youngest helped him in practical ways, changing the water for him, preparing colors, and cleaning paintbrushes. "I could have all that help because I was the master's son. I'm a spoiled child. My father never taught me anything, nor said a single thing about technique, nor even about my kimonos. He didn't want to teach me anything, thinking I needed only watch him. But watching isn't enough. When you're doing resist dyeing, you put paint into a dispenser, but if the tube is blocked with grit when you come

Kunihiko at the family workshop, 1967

to apply it, then what do you do? You have to get it out, and that's something you can't make up; you have to learn how to do it."

The Shinkansen high-speed train was brand-new. It was Japan's first technological success after World War II. It normally took six and a half hours to travel from Kyoto to Tokyo by train; on the high-speed train called Hikari, it took no more than three—which is why it became the symbol of Japanese modernity. It had not existed before Kuni left Japan. Kuni, who wanted his first kimono to lend some light and modernity to an old tradition, entered his *Hikari* Kimono into a competition run by Nihon Dento Kogei-Ten, a national exhibition of creative professions organized by the Ministry for Cultural Affairs and Education, in association with NHK (Japan Broadcasting Corporation), *Asahi Shinbun*, and the Association of Creative Artists.

Kakō had submitted a kimono to the same competition ten years earlier. Kuni wanted to see what the jury thought of *Hikari*. Would they feel the standard of *yuzen* technique was too low? There was a lot at stake for him: "I wanted to see if they would accept the freshness of my abstract patterns. Because in theory they were there to discover new talent. When I told my father that I wanted to take part in the competition, he gave me his consent. But everyone, including him, was skeptical about the outcome."

Without specifically naming *Hikari*, the head of the Association, a great potter and historian, said: "I saw some-

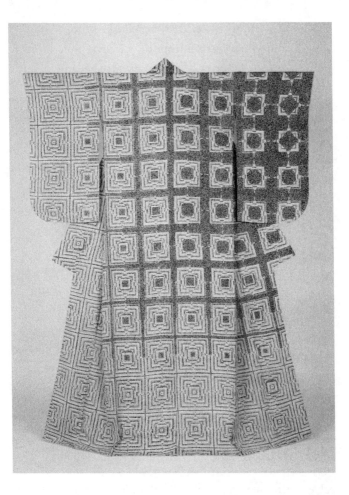

Hikari, 1967

thing in the competition that 'tasted like butter.' In other words, something 'very European.'" It may now be commonplace to use butter in Japan, but at the time it was a hallmark of Western cuisine. Kunihiko was not expecting this sort of comment; he thought his patterns could potentially be reminiscent of rigorously square prehistoric Chinese bronzes. He needed complete stylistic freedom in order to be creative and to differentiate himself from his father. His geometric patterns were accepted by the competition; he now needed to find his place in the furtherance of tradition.

In 1967, he came across a text by a historian at Kyoto University that reassured him in his vision to extend tradition: "With something like the ancient architecture of temples, we must preserve tradition, but with art, which involves a living mind, tradition can become a hindrance. We must keep asking ourselves whether tradition is handed down correctly and whether previous results have been properly passed on to the next generation. We must analyze the past to be sure we don't keep making the same thing."

He was explicitly opposed to easy options and the potential self-satisfaction that lies in wait for artists when they stop reinventing their work and simply repeat themselves without taking risks. The Association should have nurtured and rewarded freedom of expression and adventure. He thought the juries of these competitions should have been able to detect and honor novelty; otherwise the system meant nothing. After the war, in the Association's first five years, its juries had discovered and promoted

artists such as Kakō Moriguchi and Fukumi Shimura, both of whom expressed remarkable sensitivity through color. A decade later, the jury was looking for something new and fresh, to energize its institution and the world of arts and crafts.

KEIKO

KUNIHIKO MORIGUCHI met Keiko Terada in Tokyo, thanks to the intervention of a former sumo wrestler who was a friend of his parents. When Kuni first saw Keiko he was immediately struck by her charm: her clear face and radiant smile, her natural refinement, and her endearing joie de vivre. He knew that it was with her that he wanted to spend his life. Nothing had been arranged for the first date, so the former wrestler's wife suggested they go to a sumo match. For the couple-to-be, who hardly knew each other, this would allow them to avoid a more face-to-face meeting, which might have proved awkward. Afterward, they went for dinner at a French restaurant in Ginza. It was a whole new experience for Keiko. Kuni escorted her home in the south of the city, arriving so late that Keiko's father was displeased.

Just before the wedding, September 1975

The Museum of Modern Art, Shiga, 2009

The wedding took place in Kyoto four months later, on October 1, 1975. The reception brought together three hundred guests. In the photographs taken at the reception, Kuni is in a tuxedo with a bow tie and a white ruffled dress shirt; Keiko wears a red striped kimono and a green obi, with her hair piled up in a high bun and embellished with red and gold jewels. The photograph of the marriage ceremony at Kamigamo Shrine shows them in traditional dress. Keiko wears a white hat and a kimono painted by Kakō—white with a pattern of cranes, considered one of the artist's masterpieces. Kuni wears a ceremonial black kimono, pleated black and white striped pants, and an open jacket called a *haori*. They are posing in a Shinto temple setting. The image consecrates Kuni's choice of Keiko as his wife, but also his decision to wed himself to his country's traditions at a time when the Japanese tended to be more drawn to North American style and blaring modernity.

Kunihiko's commitment to the *yuzen* ethos was total, which meant he must live under his father's roof, close to the workshop. This was a choice that Keiko must embrace too. Before the marriage he had therefore asked her whether she would agree to come and live with his parents, explaining that what was at stake here was the transmission of a whole culture—not only its techniques but the thought process that underpinned it. She had given her consent, perhaps not foreseeing the consequences of this decision. Two weeks before the wedding, she had already

moved in with all her belongings packed into a large truck: wardrobes, books, dressing table, armchairs, and clothes.

To this day Kuni is grateful to her for the sacrifices she made by coming to live in his family home. "I needed to live here full-time, because things might happen in the evening and I didn't want to miss anything. What she agreed to was huge. If I've succeeded in life, it's thanks to her discretion and generosity."

Keiko's father was a dentist, and before she met Kunihiko, she had helped in his office. She was not equipped to live in the austere world of *yuzen*, even though her parents were "old school." She was not taught how to be mistress of a household, because this was technically her mother-in-law's prerogative. But she set off on this adventure with Kuni, guided solely by the strength of her feelings, and by her continued commitment to marriage and its attendant precepts.

When I was filming Kuni in the family home, I very soon saw the important role that Keiko played in her husband's life and work; in order to transliterate this fact, I came up with the idea of asking her to share her recipes, speaking to the camera. It has to be said that Keiko is a wonderful cook, of both French and Japanese dishes. While she busied away, our happy conversations about culinary features, and the appearance and taste of various ingredients, satisfied one of my great sources of curiosity about Japan. Keiko and I did not share a language, so cooking became our common ground for communication. She offered me new dishes

every day, laughing as she announced them out loud with Kuni translating. When I had tasted the food, I commented with Japanese expressions, always the same ones—"*Oishi! Oishi!*," "It's good," "It's delicious"—accompanied by the little grunts of satisfaction that I had heard at the tea ceremony in Matsushita.

I sincerely believe that Keiko's cooking was a creative act that echoed Kuni's: appearance, consistency, color, diversity, freshness, harmony, cut, history...the multiple dishes, or "tastes," provided at each meal gave the privileged and familiar guest that I was an extraordinary palette of aesthetic and gustatory sensations. It was not a case of eating a preconceived plateful of food, as I would expect to in France, but of composing my own succession of flavors, nuances, and textures in whatever order appealed to me, using chopsticks to gather things almost casually while the conversation flowed.

Roland Barthes refers to the purpose of chopsticks in *Empire of Signs*: "The function of a chopstick—as its shape amply implies—is deictic: it points to the food, singles out a fragment, and by this very process of selection as an index finger [...] it brings the chopstick into being, indicating what it chooses (and therefore instantly choosing *this* and not *that*); it introduces into our food-related etiquette not order but capriciousness, a sort of indolence: in any event, a calculated gesture rather than a mechanical one."

In Japan, at home and in restaurants, people decide individually what they take and what they want to eat, and

everything is shared because they are all serving themselves from the same dishes. With this system it is possible to eat for hours on end while talking, which is very different from our Western behavior, where the meal is entirely focused around a main course that is carved up with knife and fork and eaten in a flash, leaving diners replete and sometimes dazed, with the cheese still to come.

I filmed day-to-day life, seeing the workshop, kitchen, living rooms, and small garden together as a living body with its various organs. All these elements contributed to the creative spirit — of Moriguchi father and son — that I wanted to portray. I filmed everything: a door sliding aside to reveal one or the other of them, rain gliding over plant leaves, bamboo blinds clacking against a window, Keiko preparing a meal, and a student grinding raw materials to make colors. All this was more important to me than precisely knowing each stage and technique in *yuzen* production. Others took care of representing that. Significantly, I now understood from the inside why Kuni had decided to live alongside his father, in this house, despite the constraints that this might impose on a young couple. The workshop and *yuzen* embraced the whole household. A culture that affected every aspect of life, a distinctive way of being Japanese.

Among these delectable little incidents, I witnessed a visit from a fishmonger who came to the house regularly. Keiko was waiting for him by the front door with her apron

fluttering in the wind. He arrived with a stack of three polystyrene trays and set them on the ground in front of Keiko, like a market stall. The trays contained about twenty neatly arranged fillets of different fish as well as sea urchins and raw prawns, all of them carefully covered with sheets of cellophane. Although I did not understand what they were saying, I could see that the salesman was exaggeratedly polite with Keiko. The person who later translated their exchange added a brief personal commentary for my benefit: "They both keep saying '*Sumimasen*,' which means 'Sorry.' The word has several meanings for us, such as 'Thank you,' 'Excuse me,' 'I'm so sorry, I'm disturbing you.' We use it to belittle ourselves, when we want to appear modest." Then came the translation. The text was littered with *sumimasen*, in the same way that STOP once punctuated snatches of words in telegrams.

KEIKO: *Sumimasen*, come in, please.

FISHMONGER: *Sumimasen*, sorry to disturb you.

KEIKO: No, no, *sumimasen*. It smells good!

FISHMONGER: *Sumimasen*.

KEIKO: What would you recommend? *Hamachi* [yellowtail flounder], *tachiuo* [swordfish], *amaebi* [sweet shrimp], do you have what I'd need for an *otsukuri* [sashimi requiring very fresh fish]?

FISHMONGER: I have sea urchins, *amaebi*, and this *hamachi*, which is already cut up, and I have another one uncut back at the shop.

KEIKO: I'll take enough of this *hamachi* for two people.

FISHMONGER: Okay. *Sumimasen*, thank you very much. *Sumimasen*. One thousand yen, please.

KEIKO: Exactly one thousand yen? I don't have any change, I'm so sorry.

FISHMONGER: That's no problem. *Sumimasen*. We'll be closed next Wednesday. Yes, we're very sorry, thank you for being so understanding. Yes, *sumimasen*, I'll take the bill. Thank you. And give you the change. Thank you very much. *Sumimasen*. Thank you very much for all eternity.

KEIKO: Thank you very much.

FISHMONGER: *Sumimasen*. Sorry to have disturbed you.

KEIKO: No, No.

FISHMONGER: Thank you very much. Please forgive me.

KEIKO: You take care. Thank you very much!

After closing the door on him she turned to me with a big smile and a small sigh: "It's over. He's gone." Then, laughing and brandishing balled fists like an impatient child, she added, "Lunchtime, everyone to the table!"

I also remember a visit from a man who produced home-made tofu. He did his rounds cheerfully with a small trailer hitched to the back of his bicycle, going up and down the streets with a sort of pear-shaped horn that made a plaintive two-toned sound. He was a jolly character, happy to be alive, and did not apologize for existing, as his fishmonger counterpart did. With his bare hands he delved into his metal tubs filled with water and lifted out the varieties of tofu that Keiko wanted: fresh, fried, and smoked. There

was something sensual about seeing those moist, delicate, limp white shapes emerging. Kunihiko, who had heard the horn, came out to say hello to the trader. I can still see the three of them chatting in the sunshine around the bicycle, discussing refining processes and production methods for tofu. We watched the man zigzag away toward Oike Avenue. With one arm raised in farewell, he squeezed the horn, and I then realized that the sound of this instrument, which I had initially thought of as plaintive, was in fact very jaunty, as if defying what life threw at it.

These hawkers whom I met ten years ago were part of a traditional world that has now disappeared or is in the process of disappearing.

One evening Kuni opened up to me about aspects of the life he found when he returned to his parents' home, a life into which Keiko had followed him. He himself seemed discomfited to have experienced it: "In 1965 there were three students in the house and one bathroom for everyone. Water for baths had to be heated with a wood fire. One tub of water for all of us. Keeping to a well-established order, the first to bathe was my father, then me, my sister, my mother, then the first, second, and third students, and lastly the maid. You couldn't choose when you had a bath. I'd lived in contemporary modern society and now had to put up with a feudal way of life. Keiko suffered heavy constraints too, because her relationship with her mother-in-law was difficult. She always says she was never allowed to give our first child a bath. Her mother-in-law took care of that, so she

never had that skin-to-skin contact that a mother naturally has with her child. It was like being in the imperial family. My wife accepted this situation and never complained; I can never thank her enough."

◆ ◆ ◆

KEIKO HAD GIVEN ME permission to film her, but we could not talk to each other. When we met in the house we communicated with signs: I had learned to greet her with a bow (but I did it slightly ironically, smiling to show I knew I was not bowing correctly); she would rub her shoulders and give a little frown to ask whether I was cold, or would offer me a coffee with a cup-tipping gesture, that sort of thing. This communication barrier gradually became a frustration, particularly for her, because it highlighted the distinctive nature of her relationship with Kuni and his with France.

Kuni could tolerate the feudal world of the workshop because he had lived in France and had nurtured friendships and professional relationships. He had also lived in Italy and traveled in Greece. His mind could escape. Keiko had not been so lucky. Thanks to a translator, she was able to confide in me: "I think that speaking French was a deliverance for Kuni, who had chosen to live in Kyoto's Japanese-style society. He had studied in France and still had friends from those days, and other acquaintances had evolved into lasting friendships. I couldn't be a part of all that, because I don't speak French."

Keiko is keenly aware of Kuni's relationship with France,

and it may be that this different life experienced by Kuni brought a breath of fresh air into the very closed world of the family workshop: "When one of [his friends] calls from France, Kuni lights up instantly. I don't speak French, but I like listening to it; it sounds like music to me. Sometimes I understand a little, I try to guess who's calling, and I ask, 'Is it so-and-so?' He almost always says yes." Keiko knows how vital France is to him: "When he seems very tired, I encourage him to go to Paris. He tells me he's greeted with open arms and feels good there. It's good that he goes once a year to unwind." When I ask whether she has considered learning French, she says, "When we got married, he suggested it to me, but my priority was taking care of the house. It really wasn't easy living with my in-laws."

The name Keiko can mean "child of joy," "child of grace," or "child of revelation." In my favorite photo of them, they are in close-up with water behind them. He is looking straight ahead, but you can see from his face that he is communicating with her as she looks at him from the side with a fond smile. That photo could easily be a still from an unforgettable Japanese film.

KIMONO

KUNIHIKO MORIGUCHI positions his work within the continuing history of the kimono and the development of *yuzen* dyeing techniques. In other words, in the narrative of tradition.

Kimonos are loose, one-size, T-shaped garments that are crossed over at the front and fastened at the waist with a belt. Making a kimono almost invariably uses twelve meters of fabric from a bolt thirty-seven centimeters wide; the fabric is cut into eight pieces that are then assembled and stitched together: two for the front, two for the back, and four for the sleeves. There are now very few people who wear them on a daily basis in Japan. They are kept for weddings, funerals, tea ceremonies, or trips to Noh or Kabuki performances. Only the wealthy, aristocrats, and museums can afford kimonos by Kakō or Kunihiko Moriguchi.

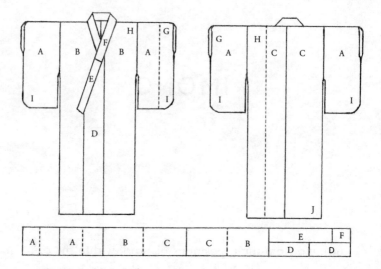

Pattern for a kimono

The kimono was introduced to Japan from China in the eighth century, and its present-day form is based on the *kosode*, a short-sleeved kimono that was fashionable in the fifteenth century. Its shape has changed very little since the eleventh century. During the Heian period (794–1184), in order to differentiate themselves from the Chinese, women at court wore the *junihitoe*, comprising twelve kimonos worn one on top of the other to create a sequence of colors at the V-shaped neckline and the ends of the sleeves. The wearer's elegance was judged on the combination of colors in relation to the seasons. The Kamakura period (1185–1333), which was marked by the ascension to power of military forces and influenced by Zen Buddhist philosophy, saw the institution of more severe, simple lines. Successive layers of kimonos were abandoned in favor of a single garment, the *kosode*, that had been an undergarment for aristocrats. It became outerwear for court samurais. The Edo period (1603–1868) was characterized by the military dictatorship of the Tokugawa shogunate and by economic growth; in this climate the *kosode* was democratized and took on sumptuous colors, with craftsmen inventing new patterns and developing innovative techniques. Sumptuary laws were introduced early in the seventeenth century in an attempt to maintain social differentiation through clothing: the middle classes must not be confused with the aristocracy.

A law forbade the embroidering or dyeing of kimonos. Details could be altered but not the garment as a whole. The use of colors was limited: red, for example, was

restricted because the pigment used to make it was rare and therefore expensive.

The middle classes, who were wealthier than lords, circumvented these restrictions by wearing cotton kimonos lined with red silk produced using different, cheaper pigments. The general population did not wear silk.

◆ ◆ ◆

MORIGUCHI now designs kimonos to showcase women. Does he pay more attention to the back or the front when he designs a kimono? "For me, the most important thing is the back, because the front is already lifted by facial expressions, makeup, and conversation. A figure seen from behind is defenseless, you can't give it a particular expression or make it speak. When you design the back of a kimono, you make allowance for the fact that part of the design will be hidden by the obi. Gaining admiration for a figure seen from the back is a challenge. My role is to make a woman's back view more beautiful — it's my way of showing them my respect. 'You can take care of the front, ladies, but leave the back to me!'"

◆ ◆ ◆

YUZEN is a resist dye method. Its name comes from Miyazaki Yuzen, a painter of fans from the second half of the sixteenth century, when Japan was enjoying a period of peace and openness. Miyazaki Yuzen's designs were an

instant runaway success with the general public, and this craze prompted the invention of the *yuzen* technique, a sort of hybrid of previous dyeing techniques. The *Dictionnaire historique du Japon* mentions a compendium published in 1688 that was called *Yuzen Patterns* and is full of praise for its aesthetics: "It respects age-old style and is in keeping with the refinement and elegance of our times. *Yuzen* is not revolutionary. Thanks both to its designs and its techniques, it belongs to the Wayo tradition, which dates back to the Heian period. It is in fact a form of resist dyeing, like batik."

Moriguchi explains to me how profoundly each era was distinguished by a particular style: the Genroku period (1688–1704) saw the appearance of the Kanbun *kosode*. During the Bunka and Bunsei periods (1804–1830), creative currents developed in Kyoto and Kamigata; although unrefined at first glance, they were in fact remarkable and would evolve toward Tokyo's restrained, refined style. "The world of *yuzen* has always developed skills that were ahead of their times; it's not a conventional skill set. The backdrop to this tradition is 'real class'; in other words, a dignity and elegance that it is important to preserve." During the Edo period, everyone visited pleasure districts such as Shimabara. Lords and men from the upper middle class could be found there in the company of beautiful women. "You see," Moriguchi told me, "that's where *yuzen* was seen at its best and appreciated. *Tayū*, *geishas*, and *oiran* were beautiful, highly educated artists, but to sleep with some of them could cost huge sums of money. Very few could afford

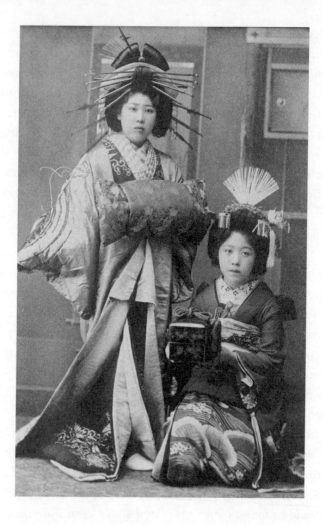

Oiran (courtesans), 1920

them. Lords lost entire fortunes. Everything happened in these districts: culture, fashion, poetry, music, and theater. Ladies from the imperial court went in disguise. Homosexual couples could be seen together. The seventeenth and eighteenth centuries saw a great deal of freedom in Japan, even though the feudal system was strict. *Yuzen* symbolized this freedom, as did engravings. They are two arts that emerged from among the populace at the same time." This was a time that showed little consideration for women: they had to be small, pretty, kind, elegant, educated, submissive, and dressed in beautiful, luxurious outfits. Perched on high wooden geta, they were further hampered by their kimonos and could take only tiny footsteps. Women became objects of beauty and diversion. Wrapped in kimonos, their bodies and curves — breasts, waists, hips, and buttocks — disappeared behind an asexual silhouette with a belt that made the overall effect reminiscent of a gift-wrapped present. True to Japanese tastes, the object of desire was hidden, whereas during the same period in France women's bodies were accentuated, their breasts on display, their waistlines reduced by tight corseting, and the outline of their hips amplified by their dresses. Aude Fieschi's *Kimono d'art et de désir* immerses the reader in the recurring themes of kimonos, most of them associated with nature:

Flowers, birds, the moon, the wind, the sea, rivers, clouds, etc. But the overall design does not feature these subjects at random, they must match the season. Cherry blossom is especially popular for the spring, waves and oceans for the summer, maple leaves adorn kimonos for

the fall, and snowscapes and plum blossom those worn in winter […] But the designs have more than an esthetic value, they are also chosen for their meaning: pine trees symbolize longevity, and bamboo, that bends in strong winds but does not break, is an allusion to man's spirit grappling with life's difficulties. When depicted with sparrows or tigers, bamboo becomes a symbol of happiness. Eagles represent strength, and are used on kimonos for boys; cranes are synonymous with luck and long life, and are associated with the new year.

During the Edo period, tradesmen and kimono makers worked together to create books of designs that included all sorts of details about colors and the painting method used. The practice of *yuzen* also revealed kimono artists — such as Kakō and Kunihiko Moriguchi — who honed their art to the point of excellence and were primarily concerned with designing elegant garments whose beauty derives from their interplay of colors, lines, and symbolic patterns and produces responses too subtle to define. This beauty touches on aspects of Japanese philosophy, the transience of the natural world, and a perception of our precarious place within it.

A mortal's own heart
Is light as a tunic
Whose dye swiftly fades.
The robe has little style
But what of its pale blue hue?
— Sakon

Artificial colorants were introduced in Japan at the start of the Meiji period, and they produced a new boom in *yuzen*. The master dyer Hirose Jisuke (1822–1896) adapted stenciling to the *yuzen* technique, which allowed for mass production. Hand-worked *yuzen* still continued, however, for top-of-the-range pieces and works of art. Stencils were used manually, not mechanically, and customers ordered from a catalogue. The kimono would arrive three months later, whereas a hand-worked piece required at least a year's work. Moriguchi says there is a subtle difference between the two. Craftsmen making one-off kimonos felt a need to differentiate themselves by reinventing their style. They were to some extent forced to be permanently innovative.

Moriguchi describes himself as a direct successor to the long history of *yuzen*. "My mission is to create and to breathe new life into this discipline, like in the early days of *yuzen*, when its artists were free. They may have been limited in their use of colors, because there were no synthetic colors, but they were in pursuit of something new. I feel I'm competing with craftsmen of the past, but not my contemporaries."

FATHER SON

HEISHICHIRŌ MORIGUCHI was born in 1909, in Moriyama in the prefecture of Shiga. His parents were landowners and ran a rice business in the region, but the economic downturn produced by the 1907 US banking crisis had plunged Japan into a deep recession. The ensuing famines in 1913 and 1914 compounded the family's ruin, and Heishichirō was taken in by an uncle who was a pharmacist. He liked to draw and used the back of small advertising posters for his drawings. By way of encouragement, his uncle exhibited his first efforts in the shop. Heishichirō Kakō was about fifteen when the *yuzen* painter Kason Nakagawa noticed his talent and took him on as an apprentice in his workshop, where he stayed for twelve years. His master, Kason, gave him the professional name Kakō as a way of publicizing his ideas. Kakō spoke with high emotion of this time when his family was

battling very difficult conditions, and he admitted to Kuni that "the only thing that could never be stolen from me was a craft." This is why he decided to improve his skills with the technique, but having always regretted that he did not study at university, he encouraged both of his sons to do so.

◆ ◆ ◆

KUNI ADMIRED HIS FATHER and the ways he found to be innovative. While most artists usually repeated the same designs over the entire surface of the fabric, Kakō developed just one design: a tree, a branch, a feather, or a wave. He used traditional themes but revisited them by giving them distinctive significance. If he painted a blossoming plum tree, or an animal such as a mandarin duck or a crane (his favorite subject), he had fun turning custom on its head with unusual color choices: the traditionally upbeat, cheerful mandarin duck would be depicted in black in a disturbing setting. "He had a way of combining two things from opposite poles, and the results were spectacular," Kuni marveled. Kakō's drawing was sharp and taut, giving an impression of dynamic movement that matched the very essence of the subject. He also succeeded in bringing back into fashion an old technique called *makinori*, and its flecked effect is a distinguishing trait of his kimonos. This technique became his hallmark.

Kakō's art was recognized and widely acclaimed until the end of his life. In 1955, he was awarded the Grand Prize at

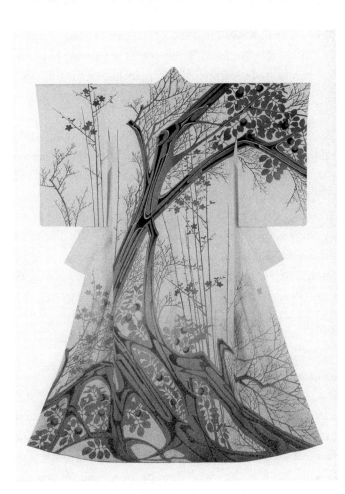

A kimono by Kakō Moriguchi, 1959

Nihon-Dento-Kogei-Ten, the first state-organized exhibition of "Intangible National Treasures." He painted kimonos for members of the imperial family, including the one worn by the empress during the queen of England's 1975 visit.

To Kunihiko, his father indisputably incarnated an admirable artist, but perhaps he was also an inhibiting presence. How to survive in a house where everything centered around this successful father? Kakō was named a Living National Treasure, the highest distinction for an artist craftsman, in the year that Kuni returned to Japan. What sort of place could Kuni hope to make for himself alongside him? Should we see this as one of the reasons for his wanting to move away from the family home and travel to France?

◆ ◆ ◆

IN 2009, I ended up in Tokyo making a documentary about marginalized youths in Japan. Moriguchi was preparing for a major exhibition featuring both his father's kimonos and his own. His father's death the previous year had brought forward my planned filming, originally scheduled for 2011. I wanted to film the installation of the exhibition and the private viewing, because this unique event came at a time when Kunihiko might broach the question of a legacy in an emotional and positive light.

The Museum of Modern Art was in Shiga, near Lake Biwa. The walls inside the building featured floor-to-ceiling win-

dows, and in the central atrium workmen in blue overalls (so faded they were in fact gray!) and white gloves very carefully opened wooden crates and lifted out long cardboard boxes. The museum's conservator and his assistant then took over to extricate the kimonos, methodically removing the packaging of fabric or white paper. The way in which they handled and unfurled them indicated that they regarded each piece as priceless. It was the first time I had seen a hand-painted kimono at such close quarters. What struck me immediately was the texture of the fabric; it seemed dense and heavy. Next I noticed the powerful colors and the sophistication of the images.

The sixty kimonos, all identical in size, were hung on rails in a way that best displayed the painted designs, then they were arranged in the tall windows in a predetermined sequence. Kuni stood in the middle of the room to see the effect produced by this succession of kimonos on their individual rails, his father's and his own face-to-face, like human forms. And then, as if talking to himself, he said, "Well, my father never got to see this…shame." Noticing that I had heard him, he added, "Next to these"—indicating Kakō's kimonos—"it really does look as if a baby did these"—pointing to his own work. "But a baby with a lot of drive; it's a battle between a grown man and a little baby. I don't know if my father understood what I was doing. But at least I've done something that my father couldn't do.

Kakō had started his work at fifteen; Kuni, at twenty-six. Our muscles change and grow up to the age of twenty-five;

after that everything goes downhill. Some movements are restricted; the hands and shoulders tire more quickly. Only experience can offer a different sort of acuity, but after a certain age it is no longer possible to make progress with the craft's techniques.

Kuni was more optimistic about every aspect of his inspiration and choice of designs; here his work could be compared with his father's. "We were both inspired by the fact that we worship, respect, and love women. It's a different way of loving women that we each express in our own style, and it bears comparison because we're completely different."

I could not see myself working with my father in the same space for years on end, as Kunihiko had done. It would not have worked. Just as Kuni had traveled to France to find a different environment in which to become himself, I too had left home, at the same age as Kuni, when I was an art student. I went to Haiti to discover a different world, one I thought more authentic than my own country, which seemed fossilized to me. I struggled to understand how Kuni turned his back on the country he had chosen, France, where he had gained so much experience and met exceptional people, only to return to the constraints of the family home he had escaped in the first place.

He had committed himself to this new craft as others might devote themselves to a religion. He isolated himself from the modern way of life in order to embrace a traditional one that had not changed for perhaps two hundred

years. Kuni explained that these measures guaranteed authenticity in his practice of the craft. The handing down of a culture from one generation to the next should happen within the home, which is a place of work as well as a place to live. "There's something that can be passed on like this from generation to generation, but you can't really talk about it. What's handed down is a sort of philosophy of life and death, because we're all dying even while we're busy living […] I've always been driven by a concern to respect the edifice that my father built up and not to cause him any anxiety. This respect and this typically Japanese type of filial devotion are intimately bound with my desire to develop my own originality as a creator: the world of my work is the result of that symbiosis. If people understand that, I will feel gratified."

The private view of the exhibition was not as I had imagined it. Japanese customs are different from those familiar in Europe. There was a presentation in front of an audience, with the museum curator, the exhibition curator, and Kunihiko stepping up to the microphone one after the other. The guests gathered into a semicircle with a radius of about twenty meters around the speakers in the museum's vast entrance hall. The arrangement would have felt a little too formal in the West. I had some fun taking photographs of these people in their smartest clothes, showing such respect for official speeches. But when Kuni started talking I was immediately aware of his emotion: "It's thanks to the Exhibition of Traditional Crafts (Nihon-Dento-Kogei-Ten)

that the world discovered my father's talent, and mine, and that's how we became what we are today. My father and I attach a great deal of importance to tradition. There are two or three things that really matter to me, and the most important is what tradition teaches us. Do you know what the English word "dignity" means? It's on a par with that. I think it's my duty to preserve the dignity of tradition. Everyone who works in this field has the same duty. My first concern is to find out how I can preserve and perpetuate this dignity. The skills of Japanese crafts were mostly imported from China or Korea. *Yuzen* is a dynamic craft that has succeeded in asserting its style while also evolving with society. Perpetuating *yuzen* tradition means evolving and making *yuzen* style itself evolve to suit our times. That is my second concern. The third is that I must perpetuate the *makinori* technique, one of the techniques used in *yuzen*. My father devoted more than fifteen years of his career to studying it, expanding it, and adapting it to his work. My concept of *makinori* is different from my father's, and it is now incumbent on me to think of other possibilities. I work hard to pass on the art of *yuzen*, and, to achieve that, I must consider all of these elements, some of them spiritual, some tangible."

At the end of the afternoon, in keeping with the protocol of the event, Kunihiko and Keiko stood by the entrance to the exhibition to welcome all the guests. Kuni wore a dark suit and tie, with a beautiful red flower made of ribbon on his chest. Beside him, Keiko had her hair up in a bun and wore

a kimono in a stunning, intense shade of green. They stood there for a long time like young newlyweds, greeting guests who queued silently outside the exhibition hall. They said something — however brief — to each and every one.

◆ ◆ ◆

THE FEW PHOTOGRAPHS of father and son together offer little insight into their relationship. Sometimes they appear side by side, but not together. Kuni valued his father's work, but what did Kakō think of his?

"I kept waiting for my father to like what I was doing, but at the same time I rebuffed him. When I saw what a virtuoso he was, I thought, no, I can't take him on, I'm going back to France. I'd been so happy there that I admit I sometimes felt like an outsider here. At one point I even thought of leaving Japan. By coming back I'd lost all the freedom I'd found in France. Very astutely, my father encouraged me by saying, 'Why don't you become the *yuzen* painter of the post-Kakō *yuzen* generation, you'll be the Kunihiko generation!' After my first kimonos, I started to see a sort of reflection of my own work in my father's work. I felt he'd accepted me. He never criticized what I did, but responded to my work with his own. I think it took us ten years to understand each other. We didn't talk like a father and son; it had to happen of its own accord. And I was very glad that I'd influenced him a little, but I didn't dare say so. He never said anything about my kimonos to me. Even though we were together day and night. When I won my first prize, he

At home, 1960

At the Hotel Okura in Tokyo, 1988

was a member of the jury. He liked hearing what people thought of me, but never told me directly what he himself thought. That's what it was like between us. He let me criticize him. He accepted what I said. We started having frank discussions after ten years. He was prepared to accept what I told him, and he would immediately make corrections, creating a different design and asking what I thought of it."

Kakō never commented on Kuni's kimonos, but when he felt there was something missing in a design, he would ask if he could finish off the draft. He might make five or six of these drafts for one kimono. He knew that his son admired his talent and, when the piece was finished, they both shared in the pleasure of it.

In *Sand Flow* (1984), Kuni concentrated on spiral patterns that would come to life when the kimono was worn. With the same principle in mind, Kakō created a kimono decorated with the branches of a plum tree originating at the base of the collar and tapering as they reached down the back. "By imitating one of my compositions, he let me know that I was heading in the right direction. I was very happy about this, and it increased my confidence in my chosen path."

◆ ◆ ◆

IN THE CATALOGUE for an exhibition at the House of Culture of Japan in Paris, Germain Viatte refers to Kakō's

influence on Kuni with Kakō's kimono *Autumn* (1964), featuring countless droplets in motion. The kimono is black and white with discreet touches of yellow, like reflected light. Kuni reinterpreted the design with his kimono *Fresh Snow* in 1986. Kakō's influence is subtle, interiorized. Kuni told me how the snowflakes suggested themselves to him: "When I was briefly in Kanazawa, it started snowing one evening. It wasn't the poetic, swirling sort of snow. What I saw through the window and what imprinted itself on my memory were slanting lines of snow at forty-five degrees, and I used that as my starting point. The sections that have no design on them are the same as those that do, with angles like steps in a staircase. It was blue at the start, becoming gray and black. This created a sense of depth."

◆ ◆ ◆

SHOULD WE THINK OF this dazzling skill as a craft or an art, as we understand the word in the West?

"My father thought of himself as a craftsman his whole life. He even refused to contribute an exhibit to a show that officially presented craftsmen as artists. He wasn't trained to be an artist; his training was done by apprenticeship, and this status was important to him. But the way that creative professions are perceived has changed, and he became a great artist, a very great artist, famous. As for me, right from the start I wanted to make art, not craft. What's the difference? As a craftsman, you should be able to copy any design faithfully and perfectly. Whereas an artist must

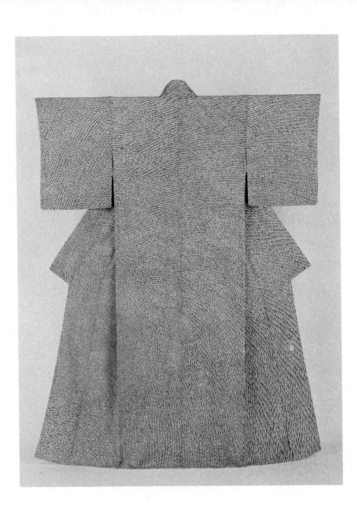

A kimono by Kakō Moriguchi, 1964

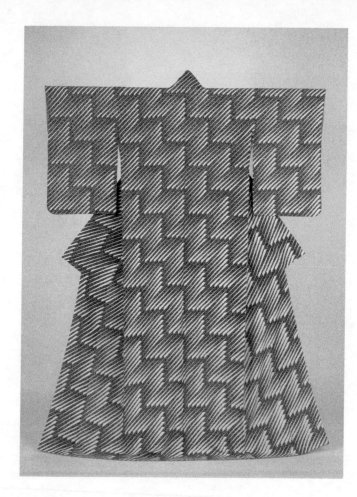

Fresh Snow, 1986

not repeat things. Was the general public aware that the craft of *yuzen* had changed categories? The modern world needed artists to continue the history of *yuzen* with new energy. But will society always agree to support this sort of movement?"

The English, Americans, Danes, and Swiss have exhibited Moriguchi's kimonos as works of art, whereas the French still see them as craft. "I don't think it's a question of art or craft anymore. My father and I talked about this, and he felt the discussion was unnecessary: it's the item itself that speaks, and says whether it's art or craft. My father used to say, 'I don't like this sort of airy-fairy, intellectual debate.'"

◆ ◆ ◆

IN 1987 Kakō had a stroke that left him partially paralyzed. In order to regain the use of his right hand, he had to undertake physical therapy that was certainly not easy given his advanced age (he was ninety-three). Day by day, Kunihiko watched the gradual decline of the father he had lived with day and night for sixty years. To thank Kakō for what he had passed on to him, Kuni decided to sacrifice his last ten years as a creator by helping his father make his own designs. Kakō completed his final kimono in 2003. It was included in the 50th Exhibition of Japanese Traditional Art Crafts later that year.

"I don't think he planned to stop, even after that show. But, physically, he could hardly work at all. We helped

him with his work, but always hanging back so that we respected the identity of each piece. My father had undergone a cataract operation, but, watching him work on that last kimono, I knew it was time he stopped. When I broached the subject, he said he wouldn't be worthy of the title of Intangible Cultural Heritage if he stopped. But he couldn't ignore his exhaustion forever. I remember him being relieved when I told him that everyone would always remember that title. He had a highly developed sense of duty. It pained him terribly that he couldn't work when he still wanted to."

On the car journey back to Kyoto the night after the show opened, we chatted and discussed the response of the general public and journalists, but Kuni's thoughts kept drifting back to his father. Seeing his kimonos again had revived memories, and he succumbed to a wave of nostalgia that he was determined to keep positive. "There was a sort of pleasing tension between my father and me, together in that little workshop day in, day out. Perhaps it was the same for him, but I certainly felt that I needed that tension; it enabled me to push the boundaries of the world I was creating. But sadly, he died last February, and since then – and it's been more than a year – I've lost that tension, and I can't be a kite without a string. I need my string to be tied to the ground. I also need to fly by myself, with air all around me. I'm alone now. A new adventure is beginning."

MORIGUCHI'S ART

MORIGUCHI'S CEREMONIAL KIMONOS are unique. The geo-metrically inspired patterns create different visual effects thanks to the interplay between the background and the foreground or the movement created when the kimonos are worn. His art is a synthesis of three-hundred-year-old techniques and modern expression. "Traditional and modern aspects live side by side in me, but there's a tension between the two forces. When we were children, we used to make telephones by connecting two cardboard boxes with a length of string. I feel as if tradition and modernity strain against each other inside me the way those play phones sometimes did. My life itself is a form of tension: if the connecting threads aren't taut enough, there's no communica-tion. There always has to be some tension for it to work."

Moriguchi's kimonos are intended for women, and

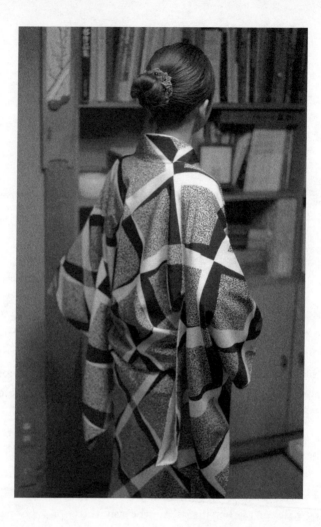

Tomoyo Moriguchi, Kunihiko's daughter-in-law

inspired by them: "Men don't surprise me, whereas women are a continuous source of surprises in my life." He sees his as a perfect profession to pay homage to women's beauty.

When he threw himself into the adventure of *yuzen*, he aimed to free women's bodies because, looking back through the history of the kimono, the garments he saw were magnificent, but they masked the wearer's figure. "People were used to looking at kimonos on display stands, like paintings. I tried to make kimonos that were as beautiful as paintings, but, once worn, their design combined with movement to reveal the beauty of the human body."

This garment, this finery, is nevertheless the preserve of a certain aristocracy. The history of *yuzen* is set against the background of a particular social class, an elegance that must be maintained. "We're all slaves to something, and I'm told that I'm a slave to women's beauty," Kuni confesses, laughing.

◆ ◆ ◆

THE SENSITIVITY of Kuni's creations and his motivation for them are rooted in living things, in studying and knowing the natural world: "As a boy, I loved animals and the wonderful patterns that clothe them. Every living thing, except for humans, is decorated with patterns. Why not us when we're part of nature? This line of questioning inspired my vocation to create patterns, through the medium of kimonos, that suit [humans], in the same way that orange and black stripes suit a tiger or black and white, a zebra."

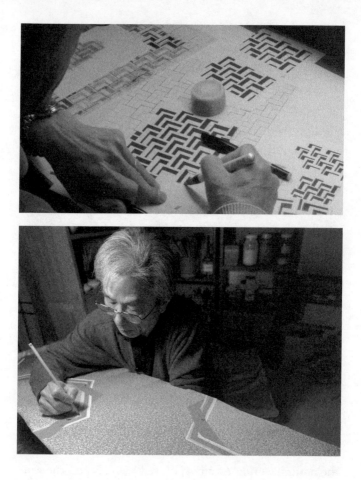

Draft

Kunihiko Moriguchi

The writer Judith Thurman, who has known Kuni for many years, devoted a remarkable article to him in *The New Yorker* in 2005. She comments on the fact that his works are inspired by Buddhist landscaping principles: "They are abstract distillations of sand, snow, moonbeams, a riverbed, a flowering cliff, or a harrowed field. 'Dawn' is a vertical arrangement of white trapezoids on a turquoise ground. 'Darkness' has the sombre beauty of a raked gravel garden. But his latest kimonos, like their sashes, take liberties with a certain notion of decorum. They are enlivened with freewheeling circles, triangular sawteeth, or asymmetrical zigzags in grayed pastels. A pattern of silvery filaments against a pointillist sky seems to celebrate Japan's famous suspension bridges."

Color is an important element in Kuni's work, even though he has occasionally sought to break free of it by producing radical black and white pieces. He remembers being drawn to dark green as a child. He has no idea why. It is a mysterious color, difficult to manufacture, unstable, varying from blue through to yellow, and impossible to create using vegetable dyes to this day.

The colors Kuni uses mostly come from natural sources: indigo, cochineal, powdered shells or onion skins, or crushed minerals. Traditional white is obtained by grinding oyster shells and adding water.

◆ ◆ ◆

AS FOR the artistic influences for Kuni's geometric designs, they come from Op Art, which he discovered at art school in Paris; more specifically from Victor Vasarely and the British painter Bridget Riley, who used repeated shapes to produce optical illusions. For example, in Riley's black and white painting *Movement in Squares* (1961), the perception of orderly geometric figures is disrupted by altering their shape, creating the impression of movement.

During one of those never-ending conversations that I so enjoy having with Kuni, I asked him who his masters were. To my great surprise, before Western influences or a boundless predilection for geometry or mathematics, he is inspired by nature, an orderliness that gives rise to harmony and diversity: evergreen trees, deciduous trees, amphibious animals, flying animals, mammals. And to clarify his creative process for me, he referred to the gardens at the Matsushita Foundation: "There's an order in nature, and gardeners are in partnership with it. How do we grow trees and prune them without destroying nature's work but making it even more beautiful?" He concluded that it was a question of rhythm and orderliness: "I do what a gardener does." His approach is to draw on nature and take inspiration from it in order to get to the heart of it and then to reproduce it in geometric patterns. This was how he proceeded with *Senka* (*A Thousand Flowers*, 1969), one of the pieces that marks a turning point in his creative output. The composition is based on hexagonal figures linked by zigzags. The starting point is

the age-old hexagonal design used in Arab mosques and cupolas. "Still respecting this structure, I then had the idea of cutting the shape in two and using the equivalent of a traditional Japanese key pattern at ninety degrees to it. I removed elements of the design and kept on repeating the shapes. I was interested in the blank spaces and wanted to use them as flowers, with a fading effect of zinc oxide white, which is a symbol of modern *yuzen*. By alternating wider and narrower blank spaces, I could see that the design was starting to move, then to swim before my eyes, with the background becoming more important as the hexagons disappeared and transformed into three-armed helices. I'd followed a logical progression and then, at some point, I deliberately broke away from that logic. The blanks became the shape. Once released from that geometric base, I was free while still respecting the geometric strictures. That's how I work."

Kuni also experimented with the Japanese ethic of objects that encourages respect for the raw material itself and its intrinsic qualities — I had witnessed this with those old bowls at the tea ceremony. Kuni's technique of inversing the shape-blank relationship introduced an optical illusion that allowed him to highlight the noble quality of the kimono's raw material, white silk that does not so much shine as radiate light from the inside. The fabric is not painted, so its own characteristics can be appreciated. The neighboring areas — the opaque painted blanks — contrast with the inherent white of the

The actress Maki Tamaru at the launch of the
"Liberty London × Kunihiko Moriguchi" collection, Tokyo, 2017

fabric, and this visual juxtaposition further accentuates that whiteness.

◆ ◆ ◆

IF KUNI IS NOW immersed at the core of modern life, it is because he successfully understood the core of traditional life. "Nowadays I see a sort of cohabitation of the modern and the traditional; I'm right in the middle. My form of expression is very modern, even though the way a kimono is made is still traditional. Even within the framework of set standards, I anticipate the division becoming more accentuated in the future, with the craft risking gravitating toward either a conservative approach or all-out new invention. If creativity in the field isn't accepted and it is reduced to just craftsmanship, this skill will become a sort of bygone curiosity. Some part of it must survive to be reborn someday. With tea ceremonies, flower arranging, and sports like kendo, everything changes and develops when it becomes international. Once we acknowledge this, there's no going back without considering the consequences, so we must follow this course. We're going through a very dangerous time. I don't know whether I've been useful, as Balthus hoped I would be, but I have worked in that direction while I personally fully experienced the confrontation between the modern and the traditional."

In the same way that Kuni managed to live a double life in Paris, dividing his time between the modest experiences of a foreign student and an intellectual and artistic

social scene, he also succeeded in dividing his life as an artist between his father's world of age-old craftsmanship and—because his work was exhibited in renowned galleries—the world of contemporary art in France. His kimonos now feature in the collections of prestigious museums such as the Metropolitan Museum of Art in New York and the Los Angeles County Museum of Art, as well as the British Museum and the Victoria & Albert Museum in London. His own exacting standards transcend craftsmanship to become art.

Kunihiko applies the *yuzen* method to his work on paper, where he develops ideas that are metaphysical in scope. In 1986, the Jeanne Bucher Jaeger Gallery in Paris exhibited "Mathematical Reflections on the Purity of Spring Water," a collection of thirty paintings on cobalt blue and white Japanese paper. The surface of the images is punctuated by fine, irregularly spaced, horizontal lines. In the background, in a quite different dimension, there are geometric shapes—squares, lozenges, and rectangles. The initial effect, which is then contradicted when the viewer discovers these secondary shapes, gives access to a perception of infinity. Not without a note of humor, he explains his intentions in the preface to the catalogue: "By combining traditional watercolor painting on paper with techniques for painting on silk, I hope that what I do matches the purity of spring water, which is always overflowing and constantly replaced…I sometimes wonder what's the point of going to so much trouble. There is no point, other than

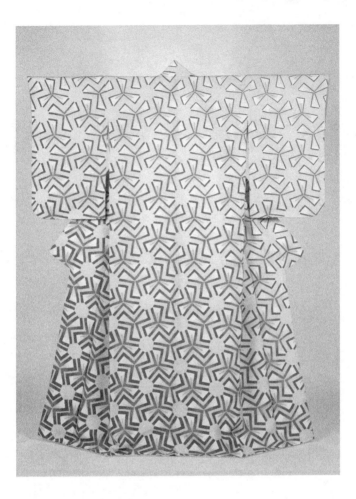

Senka, 1969

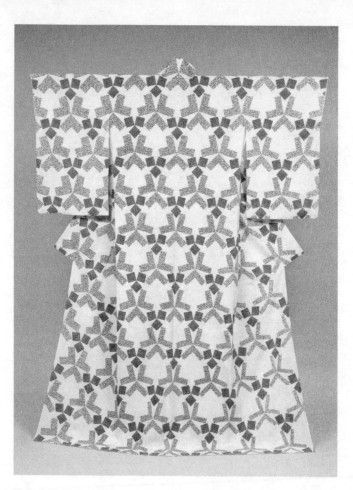

Ripening, 2013

justifying one's existence by making the effort to transcend both traditional Japanese techniques and mathematical considerations by marrying them together. Justifying one's existence means trying to achieve a degree of perfection. It is a question of a moral stance, an ethos."

Words expressed differently in one person's comments about the show: "The dialogue with nature implicates me in my own nature."

The traditional technique is a natural one, starting with the paper itself, which is made from the fibers of kozo stems washed in the icy waters of Mount Fukui, allowing nature and spirituality to work in synergy.

◆ ◆ ◆

IN 2013 Moriguchi wanted to create a synthesis of his research to date by combining hexagons with squares and using subtle shading. "Don't have too much fun," one critic told him. "What he meant was: Don't show off your skills too much. But I still had fun. I always try to have a foreground and a background where the eye should come to rest." He chose its title, *Ripening (Minori)*, because the finished piece reminded him of ripe fruit bending the branches of a tree. The kimono was bought by Mitsukoshi, a Japanese department store established more than 360 years ago that has always been the kingdom of kimonos, supplying them most notably to the imperial family. Mitsukoshi asked Moriguchi to redesign its paper shopping bags, and the new bags exactly replicated the *Ripening*

design. Later, he chose a pattern based on this same design as part of the Transmissions Croisées art exchange program. The workshops of the prestigious French porcelain producers Manufacture nationale de Sèvres also invited him to provide the graphic design for a coffee service, and here too he reworked the *Ripening* pattern. Basing his concept on the identity of the house of Sèvres, he successfully accentuated the white of the porcelain with the same subtlety as he does the immaculate white of kimono silk. The design was adjusted so that the blanks were at least as large as the patterns, allowing the gaps to become patterns in themselves and the composition as a whole to reference the Taoist duality of yin and yang. Most significantly, though, more than fifty years after leaving art school, Moriguchi was reunited with Paris and his thwarted vocation as a graphic designer.

LIVING TREASURE

ONE BEAUTIFUL, BRIGHT, crisp winter's morning, Mr. Tokuda from the Matsushita Foundation came to Kuni's house with two coworkers. He was there to return a kimono that had been presented to the foundation as part of a show devoted to works by Living National Treasures. We were sitting cross-legged on floor cushions in the reception room that opened onto the street. There were tatamis on the floor, a low-level table, and, next to the sliding door made of wood and paper, a kimono stand in lacquered wood. After chatting about one thing and another over biscuits and tea, they turned their conversation to the subject of my presence as a cameraman in the life of this Living National Treasure, Kunihiko Moriguchi. I filmed their discussion without knowing what was being said and did not have it translated until I returned to France two months later.

MR. TOKUDA: It can't be easy living like this, being filmed all the time.

KUNI: I'm going to try to change things so that it's not like this every day.

MR. TOKUDA, SURPRISED: Is the camera here the whole time?

KEIKO, SMILING: The camera follows us everywhere.

MR. TOKUDA, TRYING TO IMAGINE WHAT IT'S LIKE FOR THEM: Close surveillance!

KEIKO STIFLES A LAUGH: It'll soon come with us when we walk the dog.

Then, after a silence,

MR. TOKUDA CONTINUES MORE SERIOUSLY: Foreigners have a different view of our heritage. They might be able to reveal a different aspect of it to us, one that we, the Japanese, don't know.

KUNI, LUCID AS EVER: Foreigners can appreciate our culture, even if there are misunderstandings. But I'm not sure that even the Japanese understand our craft.

MR. TOKUDA: The Japanese think that it's difficult to talk to Living National Treasures. I tell them that the great masters are very open and take all the time they need to answer our stupid questions, but as far as most people are concerned, you live in a world apart. No one dares come to see you, because you have an exceptional artistic gift and very high social standing. People are afraid they won't be worthy of Living National Treasures. But I know that's just a preconception and I would say,

Master Moriguchi, that you can be as straightforward as
the rest of us in an everyday conversation.

When I told a friend of mine about this, she smiled
and said that the Japanese love being frightened and enjoy
seeing these human monuments as awe-inspiring and
inaccessible.

◆ ◆ ◆

THE TITLE of Living National Treasure is unique to Japan.
It originated early in the Meiji era (1868), a time when Japan
became open to international exchanges and Western-style
economic development. Japanese leaders of the time were
keen to preserve their traditional culture, concerned that
it would be threatened by contact with the Western world,
and they sought to protect and promote their culture in
the same way as they did these emerging modern ways.
The concept of Living National Treasures first appeared
in 1897 in a law protecting ancient sanctuaries and tem-
ples. At around the same time, in 1887, the idea of classi-
fying and protecting historical monuments developed in
France. In 1929, new legislation in Japan extended protec-
tion for public cultural assets to private assets, in order to
limit their destruction or exportation. It was during the
American occupation after World War II, under the influ-
ence of American historians and a French orientalist of
Russian descent, Serge Elisséeff, that a law was introduced
offering wider, collective protection for Japanese cultural

heritage. This law instituted the concepts of tangible culture (landscapes, gardens, and temples) and intangible culture (classical theater, music, and other traditional creative professions). It made it possible to protect all the arts, including those that had been considered minor at the beginning of the century. In 1954, as a way of encouraging young people to practice these crafts and develop cottage industries, the country started arranging exhibitions of works of traditional applied arts that were selected through competitions.

In Japan there are currently around one hundred people named by the state as Living National Treasures, or artists officially recognized as "Preservers of Important Intangible Cultural Properties." There are representatives of all the arts, such as ceramics, doll-making, sword-making, pottery, textiles, and woodwork, but also living arts such as Nō, Kabuki, and Bunraku. The holders of these titles receive an annual state grant of two million yen (approximately $18,500), allowing them to pursue their creativity using traditional skills but also to train apprentices to ensure the continuation of these arts and their techniques.

Kakō Moriguchi was named a Living National Treasure in 1967. The appointing committee comprised leading regional curators, descendants of historical lords, art historians, and the director of the Tokyo National Museum. In all there were some ten people, including Mr. Yukio Yashiro, an art historian who specialized in Botticelli and had been a pupil of Bernard Berenson. Ten years earlier,

Kakō had been the subject of a first appraisal, but the committee had not given him the title then because his master was still alive. When Kakō's title was announced, press and television journalists came to the house to find out who this new Living National Treasure was. It was a source of great celebration, with bouquets of flowers, congratulations, and a reception at the Ministry of Culture in Tokyo, during which he was given his certificate. Kakō and his wife were honored by everyone they met, including the imperial couple, who — true to custom — invited them for tea at the palace. "The emperor is the symbol of unity in the Japanese people," Kuni told me. "And our arts and crafts are part of the identity of Japanese unity."

It felt natural to Kuni to make himself available to help his father, finding the official documents and photographs that the press asked for: "That was how I really discovered his kimonos and the way his work evolved. I took care of organizing his archives, which made me his most attentive secretary, and it reassured me knowing that he could continue his work in the meantime." Following on from this, Kuni guided his father to become the perfect, most representative Living National Treasure, one of the best in Japan. Patiently and tactfully, he walked alongside his father on a path that made the most stringent artistic demands on him.

When Kuni in turn was named a Living National Treasure in 2007, his father was still alive but sadly could no longer communicate. The Moriguchi family was unique. This distinction can be given to a father and son after the

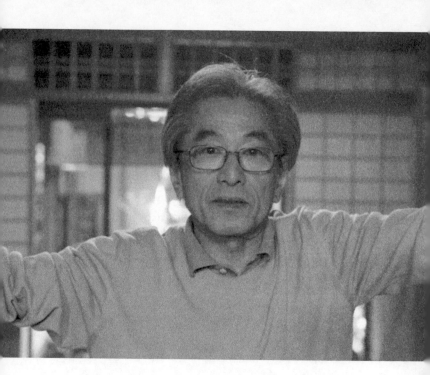

Kunihiko at home, 2011

father's death, in recognition of a skill being passed on to the next generation. But to honor both father and son in their lifetimes was a recognition of the exceptional nature of their separate and very different work, but also of a craft successfully handed down.

Even so, when Kuni received the telephone call asking him whether he would accept the title of Living National Treasure, he needed time to think. He was afraid of losing his freedom, and remembered that the great potter Kanjirō Kawai had refused the title along with all other official honors. Kanjirō did not sign his work, reflecting his conviction that art transcended the individual. Kuni's other concern was that he would be watched, hounded by the media, fellow artists, and the general public: "If we go wrong, we're judged and criticized. Particularly as we're subsidized."

I have met Moriguchi's friend Takeshi Kitamura, a Living National Treasure for specialized weaving techniques (*ra* and *tatenishiki*). He too told me that it was a complicated situation; the title is a mark of supreme, irreproachable merit and anyone who holds it is duty-bound to be perfect as a person. "People have this idea that Living National Treasures are sort of superheroes who can do anything, and they're permanently watched and judged for their behavior, so they end up feeling that the social aspect is more important than the artistic one."

Kunihiko Moriguchi now has both individual and collective responsibility for his family, his craft, and his country's identity. He cannot shy away from it; his life and his honor are at stake. He is part of the national association,

the Nihon-Kogei-Kai, through which all Living National Treasures pass on their knowledge to other Living National Treasures. Their conversations are frank, and everything is open for discussion. Kunihiko is the repository for a tradition that has successfully evolved over three centuries. He has expressed his allegiance to the contemporary world by using silkworm cocoons from Brazil, chemical dyes, and patterns based on optical and mathematical concepts, rather than locking himself into blind repetition of traditions. Therein lies his freedom.

◆ ◆ ◆

WHILE I WAS FILMING, I asked Kuni whether he thought his children would take over from him. Both his sons have been to university: the elder of the two was lucky enough to secure a place at Southampton College in the United States, and to study computer graphics, film, and music, but he has not yet found his chosen career. Kuni told me that passing on a tradition in the family must not be forced; it was up to each generation to decide. His role was to wait for them, to give them the opportunity to do it, and, if he could, to help them without a word, as his own father had done. But he felt that, in this globalized world, the young were no longer interested in traditional ways of life, and that the very identity of the Japanese people was threatened.

While Kuni's first son was in the United States, his younger son worked in the workshop with his student.

In his second year, the older brother returned from the United States to live at home. The younger brother stopped working on fabric and switched to the computer to help his father run the workshop. The older brother, with his knowledge of graphics, made a few attempts at designs, but gave up. I have a clear image of this first son working a few meters away from Kuni. The father's movements were focused, swift, and precise. His son wore headphones, and his slow, slightly hesitant movements seemed to be dictated by the music rather than by an urge to create.

As his father did after World War II, Kuni has experienced times of great poverty. Part of the regional economy once depended on the production of arts and crafts, and this created competition among craftspeople. More and more items that were traditionally made by hand are now manufactured abroad and imported, slashing prices of Japanese-made craftwork and lowering production standards. Confronted with this situation, the government is trying to safeguard these vanishing skills, but traditional craftwork is no longer profitable, except perhaps in the case of establishments that have survived for generations.

Kitamura did not have Moriguchi's luck. He was not able to stay at school but was forced to work at a very early age to help support his family. He now feels that the route mapped out by Japanese ancestors offers no true prospects in the modern world: "I worked without thinking about it for days, months, and my hands and body learned the

moves and mastered the techniques. I was surrounded by experts and fellow workers with more experience than I had, and I could watch them to learn their knacks and secrets. It was hard work, but I learned by copying them. The whole environment trained us. Even if the young want to learn a skill, there isn't the right environment now."

Modern life appears to be incompatible with traditional apprenticeship and the mindset of passing skills from master to pupil. Those who attend further education now have an opinion about things, and are only too ready to express their feelings about working conditions and artistic choices before they have in-depth knowledge of the skills themselves. Our consumer society has given them a taste for comfort and pleasure, and they see handmade creations more as art than as craftwork. "At first it was your art that you were passing on; now it's become the technicalities of a skill. The concept of a master doesn't exist," Moriguchi concludes.

"No milestones, no measures in this huge distance. There's nothing before me, there will be nothing after me: I am." When I think about these words of Gaëtan Picon's, words that Kuni quoted to me, I picture him in all his excellence and isolation as an artist, rather like Balthus, one of the last survivors of a disappearing world.

THE PURITY OF WATER

ON MARCH 11, 2011, I was with Kunihiko when a violent earthquake followed by a tsunami ravaged the Fukushima region and struck the nuclear power station, causing a disaster that is a source of international concern to this day. For the next few days we were in shock as we watched television news together and, with each passing hour, learned more about the irreversible damage and the mounting death toll. Images of that black wave are still engraved on our minds as it plied between houses, carrying off boats and cars as if they were corks, and swept aside every obstacle inland. We were frightened and even discussed leaving, all of us together, heading for the south of Japan or perhaps even another country. Then all at once Kunihiko said, "I can't leave. Leaving means abandoning our home. And how will we know when we can return to Kyoto? I want to

live with the Japanese; I want to die with all of them if need be. I can't leave them."

I told him that I thought his personal sense of collective responsibility was commendable, but that, in similar circumstances, French people's first reflex would have been to get away. In those very specific circumstances he felt more Japanese than French: "The more I get to know you, the more I like you and the more different I feel from you, from the French. I don't feel very far removed. Just different. You live with duality: good and bad, old and young. Here, when we talk about aging, we accept being old. What we don't accept is going against nature. Even though nature is very tough on us, we love it. We're devastated by earthquakes, volcanoes, and storms, but that's the way it goes. We must learn lessons from disasters; otherwise we would have to accept that all those people died for nothing."

Impermanence is an essential characteristic in Japan: "Water flows along a river, just like life. It changes the whole time but the water exists and the river exists, and even if all the waves look similar, they are never the same. We accept this impermanence and we look for permanence in crafts, in work, and in the perfection of what we do." To illustrate this idea of permanence in a skill, Kuni liked using the example of the Ise Grand Shrine, which was rebuilt exactly the same every twenty years. This temple, which is dedicated to the ancestral goddess Amaterasu, was first constructed at the end of the seventh century. The age-old structure is regularly brought up to the present day. The

ritual of its reconstruction appears to negate the passage of time, unlike in the West, where monuments are intended to last as they are for as long as possible, therefore becoming vestiges of the past that remind us of previous civilizations. In Japan, passing on a tradition means passing on heritage through which the past survives in the present.

In order to rebuild an Ise temple, two neighboring sites are reserved together, and after fifteen years, the new base is constructed. Five years later, the exact same edifice is built using new wood. Three generations of carpenters take over from one another. When the work is finished, the old temple is destroyed, and the parts of it that are still in good condition are salvaged and given away. Traditionally, all the construction tools are made from scratch every twenty years. For a number of years now, some of these tools have been kept, whereas previously they were buried and forgotten, and the skills to make them were handed down. After World War II, wood became scarce because of extensive bombing. Only one particular mountain that belonged to the imperial family could provide tall, straight trees. But transporting wood was very expensive, so trees were planted around the temples, and this new forest was carefully husbanded. It is unique across the world, a living culture.

◆ ◆ ◆

A FEW DAYS LATER we were standing in the small inner garden, watching a thin stream of water fall from a bamboo spout into an old stone basin already full to the brim.

Leaning against the bleached wooden upright on the patio, Kuni said, "For me, tradition is like the purity of spring water. There always needs to be water falling into pure water. When it's dirty, it overflows. And so it's always kept pure. And I'm just one droplet in history. That's how I see tradition."

The reverberations of these spontaneous yet serious words invited contemplation. We stood there together for an unquantifiable time, watching the sunlight through the leaves of a small plum tree. And on the polished slate steps those leaves sketched fragile patches of light and shade, random shifting shapes at the whim of the wind.

ACKNOWLEDGMENTS

TO THE MEMORY OF Pierre-André Picon, thanks to whom I met Kunihiko Moriguchi, his "Japanese brother."

My warmest thanks to Setsuko Klossowska de Rola, Jean-Philippe Lenclos, Francis Metzler, Martine Picon, Judith Thurman, Germain Viatte, and Philippe Weisbecker, as well as Corinne Atlan, Charlotte Fouchet-Ishii, Yuko Hitomi, Takeshi Kitamura, Sumiko Oé-Gottini, the Perrin family, Yoshihito Tokuda, and Michel Wasserman.

◆ ◆ ◆

THIS BOOK was written with the support of the Centre National du Livre, the Villa Kujoyama, the French Institute in Japan, and the Bettencourt Schueller Foundation.

I am grateful for the participation of the French Foundation for the Study of the Japanese Language and Civilization under the aegis of the Fondation de France.

WORKS CITED

Barthes, Roland, and Richard Howard. *Empire of Signs*. Hill and Wang, 1983.

Thurman, Judith. "The Kimono Painter." *The New Yorker*, 17 October 2005, pp. 116–127.

Fieschi, Aude. *Kimono d'art et de désir*. P. Picquier, 2002.

Iwao, Seiichi, et al. *Dictionnaire historique du Japon*. Librairie Kinokuniya, 1963.

IMAGE CREDITS

pp. 9, 82, 116, 118, and 134: Photos by the author

pp. 4, 15, 23, 27, 30, 39, 44, 68, 71, 73, 78, 90, 94, 101, 108, 111, 112, 125, and 126: Photos from the Moriguchi family archives

pp. 55, 56, and 62: Photos by Jean-Philippe Lenclos

p. 122: Actress Maki Tamaru attends the "Liberty London × Moriguchi Kunihiko" Collaboration Launch at Isetan Department Store on October 25, 2017, in Tokyo, Japan. Photo © Jun Sato / WireImage via Getty Images

MARC PETITJEAN is a writer, filmmaker, and photographer. He is the author most recently of *The Heart: Frida Kahlo in Paris*. He has directed several documentaries, including *From Hiroshima to Fukushima*, on Dr. Shuntaro Hida, a survivor of the atomic bombing of Hiroshima; *Living Treasure*, about Japanese kimono painter Kunihiko Moriguchi; and *Zones grises*, on his own search for information about the life of his father, Michel Petitjean, after his death.

ADRIANA HUNTER studied French and Drama at the University of London. She has translated nearly ninety books, including Véronique Olmi's *Bakhita* and Hervé Le Tellier's *Eléctrico W*, winner of the French-American Foundation's 2013 Translation Prize in Fiction. She lives in Kent, England.